SHOOT
LIKE
WES

**ADAM WOODWARD
& LIZ SEABROOK**

**A PRACTICAL GUIDE TO CREATING YOUR
OWN WES ANDERSON PHOTOGRAPHY**

SHOOT
LIKE
WES

WHITE
LION
PUBLISHING

CONTENTS

Foreword by Robert Yeoman	07
Foreword by Laura Wilson	08
Introduction	10
Things to Consider Before You Begin	12

Further Resources:	
Recommendations	152
Filmography	153
Index	154
Biographies	159
Acknowledgements	159

CHAPTERS

1
BOTTLE ROCKET (1996):
HOW TO USE NATURAL LIGHT 18
Photo exercise:
Shooting at Magic Hour 24

2
RUSHMORE (1998):
HOW TO USE COLOUR 28
Photo exercise:
Colour Scheming 38

3
THE ROYAL TENENBAUMS (2001):
HOW TO USE GOD'S-EYE VIEW 42
Photo exercise:
Shooting from Above 50

4
THE LIFE AQUATIC WITH
STEVE ZISSOU (2004):
HOW TO WIDEN YOUR FRAME 54
Photo exercise:
Deep Focus 62

5
THE DARJEELING LIMITED (2007):
HOW TO SHOOT GROUP PORTRAITS 66
Photo exercise:
Shooting a Group 74

6
FANTASTIC MR. FOX (2009):
HOW TO USE LOW-ANGLE SHOTS 78
Photo exercise:
Hero Shots 86

7
MOONRISE KINGDOM (2012):
HOW TO SHOOT CLOSE-UPS 90
Photo exercise:
Framing Faces 98

8
THE GRAND BUDAPEST HOTEL (2014):
HOW TO CREATE SYMMETRY 102
Photo exercise:
Shot-reverse Shot 112

9
ISLE OF DOGS (2018):
HOW TO USE FIRST-PERSON POV 116
Photo exercise:
First-person Perspective 124

10
THE FRENCH DISPATCH (2021):
HOW TO USE PROPS 128
Photo exercise:
Andersonian Arrangements 136

11
ASTEROID CITY (2023):
HOW TO SHOOT BUILDINGS 140
Photo exercise:
Wide-angle Exteriors 146

FOREWORDS

ROBERT YEOMAN, CINEMATOGRAPHER

I was fortunate to be the cinematographer on many of the films that are examined in this book. Working with Wes is always both challenging and exhilarating at the same time. He constantly pushes everyone to explore new ways to achieve his filmic vision. My collaborators were some of the most amazing actors and crew members of our time and every film has been a unique life adventure and learning experience.

For any aspiring filmmaker it is useful to study the style of a director you admire. Wes has often been the subject of YouTube videos and books that outline the visual characteristics that make Wes' films so easily recognizable. Many commercials are reflections of his style. Adam and Liz have done a very thorough and entertaining presentation in this book and no doubt you will learn something new about Wes. Use these tools whenever necessary to express your own personal vision and I hope you enjoy your read!

LAURA WILSON, PHOTOGRAPHER

Owen and I were in the small apartment on Speedway he shared with his roommate, Wes Anderson. It was 1991. They were students at the University of Texas in Austin. Owen introduced us. Wes sat on the edge of a battered couch, leaning forward. He was 21 years old. We began talking. Wes had a bright, eager expression and polite manner. His lean, refined face and boyish charm impressed me. He was talkative, but quietly so – alert, quick to smile and full of a light intelligence. I certainly did not foresee what he would become, but I sensed, for sure, there was something special about Wes – a star quality, evident even then, before he himself knew his course.

After college, Wes moved to Dallas, living again in an apartment with Owen as well as Owen's brothers, Andrew and Luke. They were writing a movie, against all odds and with no connections to Hollywood. They worked on a 13-minute short which they showed us on a white sheet on our laundry room wall in Dallas. The short was quirky, lively, visually interesting and hopeful. During this time – maybe a year or so – I saw clearly how singular Wes was. He read widely, listened to music, studied the photographs of Lartigue and Richard Avedon. He watched old movies or sat alone in a chair, quietly thinking. Wes was soaking it all up. His natural curiosity and self-assurance were bolstered by a surprising mental toughness. He willed *Bottle Rocket* into being.

On the balcony of a '50s motel in Hillsboro, just a few hundred yards east of I-35, the crew and actors on *Bottle Rocket* had been setting up since dawn. The first shot on the first morning of the first day was ready. Johnny Boccaccio, the focus puller, was at the camera lens, Bob Yeoman, the cinematographer, was sitting on the camera dolly. Polly Platt, a producer, stood nearby – all old pros. The AD said, 'Quiet on the set.' The actors waited. Silence, everyone waiting for word from the director. But nothing. Platt leaned over to whisper, 'Wes,

say action' and without missing a beat, Wes, in a forceful voice said, 'Action!' Polly turned to me, 'To the manor born,' she said – and a career was launched.

Right from the first, I was interested to see how Wes worked. Because of our early friendship, I was given unusual access to photograph behind the scenes on many of Wes's movies. There is no chaos on his sets. Nothing is slipshod or haphazard. His attention to detail is everywhere evident. The actors work hard and the crews work long hours. Yet always, I sensed among the crew an appreciation, even excitement, for what Wes was trying to achieve, for his unusual approach to storytelling. Early on they knew this young director was a visionary.

Now, mid-career, after that auspicious Texas beginning – after having filmed so successfully in New York and Italy, in India, Spain and France, Wes is mature, his youthful hair no longer straight up, but long, framing his lean, intelligent face. On the set of *The French Dispatch* in Angoulême, France, I saw Wes walking from one large set across an expanse of parking lot to a second extensive set. He was talking with Adam Stockhausen, his production designer, and Bob Yeoman, his long-time cinematographer, and behind them trailed twenty or more technicians and extras – a grand phalanx of followers. There was happiness in the way Wes walked and a generosity in his smile – a confidence born of success on the narrow road to a brilliant career.

INTRODUCTION

Few directors working today have managed to capture the imagination of the filmgoing public quite like Wes Anderson. His signature aesthetic has become instantly recognizable, endearing him to a global fan base and spawning countless tributes and affectionate parodies. But there is a lot more to Wes's artistry than pastel colours and symmetrical compositions.

In this book, you will discover some of the secrets of Wes's style and learn how to apply various techniques to your own stills photography. Each chapter focuses on a specific aspect of Wes's craft within the context of a different film, from how he uses natural light to how he shoots buildings, and everything in between. All are vital to understanding how and why his work looks and feels the way it does. If you really want to get to know Wes, the best thing to do is study his films closely. But this book will give you a head start.

If you're a budding amateur photographer looking to hone your skills, or you're simply seeking fresh inspiration, *Shoot Like Wes* will equip you with all the tools you need to create compelling images that evoke the spirit of Wes's cinematic universe. From basic composition and framing techniques to using colour to create mood and experimenting with different angles, we will delve into the stylistic elements that make Wes's films so visually appealing and explore how they can be applied to photography. So less *accidentally* Wes Anderson, more *deliberately* Wes Anderson.

The photo exercises that accompany each chapter have been carefully designed to guide you step by step through the process of setting up and capturing your own images. Perhaps most importantly, this book is about more than just emulating Wes's style – it's about finding your own voice as a photographer. While Wes's singular aesthetic serves as a valuable source of inspiration, it's essential to infuse your work with your own unique perspective and vision so that you can develop your own distinctive style.

Although Wes works on full-scale productions with large crews and sizeable budgets, you don't need lots of expensive kit to achieve great results. By paying close attention to the techniques Wes has mastered over the course of his career, as outlined overleaf, you'll gain a deeper understanding of the art of visual storytelling and begin to develop the skills necessary to express yourself creatively through photography.

We've made the exercises in this book as easy to follow as possible and have avoided using overly technical language so that anyone can pick up a camera, be it a DSLR, a smartphone or even an analogue film camera, and start shooting. If you are unsure about any of the terminology used, however, you can always refer to the Useful Terms on page 17.

Whether you're drawn to Wes's meticulously composed frames, his vibrant colour palettes or his retro-styled costumes and sets, there's something in his work for every aspiring photographer to admire and learn from. So grab your camera, channel your inner Wes and start turning ordinary moments into scenes worthy of a cinematic masterpiece.

THINGS TO CONSIDER BEFORE YOU BEGIN

By the time you reach the end of this book, you should be well on your way to mastering Wes's style. But before you pick up your camera, here are some simple tips that will give you a solid foundation for taking great pictures.

GET TO KNOW WES'S STYLE

Begin by immersing yourself in Wes's films. Analyse how he composes his shots, how characters are placed within the frame, how he uses colour and the overall compositional balance of each scene. Understanding all these elements will help you with your photography endeavours.

CHOOSE THE RIGHT EQUIPMENT

To achieve a clean and consistent look, consider using a camera with manual settings, such as a DSLR or a mirrorless camera, allowing you full control over the exposure, focus and composition. Use a prime lens with a fixed focal length for sharpness and clarity, typically in the 28mm to 35mm range. You can also use a smartphone for all the exercises in this book.

SCOUT LOCATIONS

Wes's films are known for their mix of heavily stylized fictional and real-world locations. Scout for places with strong architectural elements, bold colours and clean lines. Symmetry can be found in interiors and exteriors, as well as natural and urban environments, so explore a variety of settings to find what suits your vision best.

SET UP YOUR SHOT

Before pressing the shutter, think carefully about the composition of your image. Look for a central focal point or a clear line of symmetry. Utilize architectural features, such as doorways, windows or columns, to create a balanced frame, and pay attention to the placement of objects within the scene.

MIND THE HORIZON

Whether you are shooting inside or outside, be conscious of where the horizon line is within your composition. Aligning it precisely with the middle of the frame can help when it comes to positioning your subject, as well as foreground or background objects. You can use a tripod to stabilize your camera to ensure the horizon line is central and level.

CONTROL THE LIGHTING

Lighting plays a crucial role in achieving Wes's aesthetic, especially when it comes to setting the mood or evoking specific emotions. Shooting during the magic hours of the day (sunrise or sunset) will give your images a more nostalgic or romantic glow. If shooting outside, it's best to avoid direct sunlight, as this can create harsh highlights and shadows; if you're photographing faces, deep shadows can obscure features, particularly eyes.

FOCUS ON DETAIL

Wes's films are known for their meticulous attention to detail. Incorporating certain scenic elements such as interesting patterns or textures can help to give your images more depth and a greater sense of character. If using props, think about how they complement each other and contribute to the narrative or world you are trying to create.

EXPERIMENT WITH COLOUR GRADING

Experiment with colour grading (the process of manipulating the hues, saturation and contrast in the image) to give your photos a more cinematic look. Try flattening the colour profile by lightening the shadows and bringing down the whites and highlights. You may also want to adjust the colour temperature to warm up the image and decrease the clarity to take away some of the crispness. All this can be achieved using photo-processing software such as Adobe Lightroom or Capture One, or a mobile app such as VSCO.

PRACTISE PATIENCE

Achieving the 'perfect' shot takes practice and patience. Take as much time as you can to get it right, and don't be afraid to try out different compositions, settings and lighting conditions. Make a habit of reviewing your shots regularly, as this will enable you to learn from each attempt and ultimately help you to develop and refine your photography skills.

USEFUL TERMS

Anamorphic
A type of lens that captures a wider field of view by compressing the image horizontally, creating a widescreen cinematic effect.

Aperture
The opening in a camera lens through which light passes. It is adjustable and measured in f-stops (e.g., f/2.8, f/11). A wider aperture (low f-stop) allows more light and creates a shallow depth of field, while a narrower aperture (high f-stop) allows less light and increases depth of field.

Backlit
When the main light source is behind the subject, casting shadows toward the camera. This lighting technique can be used to create silhouettes or dramatic contrast.

Depth of Field
The distance between the nearest and farthest objects in a frame where both are in relative focus. A shallow depth of field isolates the subject from the background, while a deep depth of field keeps most of the image in focus.

Focal Point
The area or subject in the frame that the viewer's eye is naturally drawn to. It should always be the point of sharpest focus and visual interest.

Horizon Line
The line in an image where the ground or water meets the sky. It is essential for composition, particularly in landscape photography or wide-angle shots, and helps establish perspective and create a sense of balance.

Leading Lines
Any compositional element that guides the viewer's eye towards the main subject or focal point of the image. By directing the viewer's attention, leading lines add depth and enhance the overall visual impact of the image.

Magic Hour
Also known as golden hour, this refers to the soft, warm natural light that occurs shortly after sunrise and just before sunset.

Negative Space
The empty or unoccupied area around the subject in an image. Depending on the desired result, adding more or less negative space can help to emphasize or isolate the focal point.

One-point Perspective
When all the horizontal lines in your frame converge into a point in the distance, usually at the centre of the frame. This is known as the vanishing point.

Rule of Thirds
A compositional guideline which divides the frame into a 3x3 grid. The key elements of the image should be placed along the lines or at their intersections, making the composition more balanced and visually appealing.

Shutter Speed
The length of time that the camera's shutter is open, allowing light to hit the sensor. Fast shutter speeds freeze motion, while slow shutter speeds create motion blur and are useful for long-exposure photography.

BOTTLE ROCKET (1996):
HOW TO USE NATURAL LIGHT

Bottle Rocket (1996)

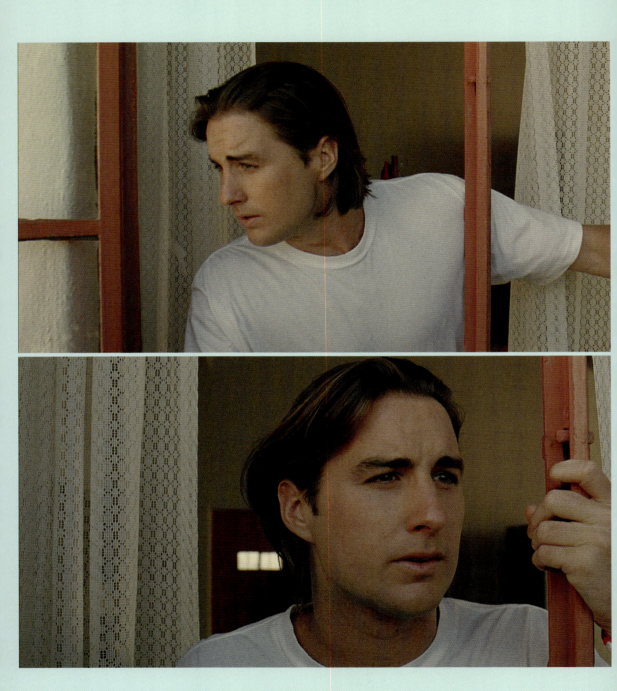

How to use natural light

Anyone familiar with Wes's distinctive visual style, particularly the interplay between light and colour which characterizes his films, may be surprised to learn that he shot his first short film entirely in black-and-white. Yet while the 1994 version of *Bottle Rocket* utilizes a high-contrast monochrome palette in homage to the French New Wave cinema that Wes adored in his formative years, the director's decision to switch to full colour for his debut feature signalled his own aesthetic sensibilities coming to the fore.

Wes's debut feature, *Bottle Rocket* (1996), is notable for its use of natural light, with numerous scenes filmed during the brief windows before sunrise and after sunset when the light attains a warm, pinkish hue, commonly referred to as 'magic hour'.

Magic Hour Moments

Today, Wes is best known for crafting highly stylized worlds in which the audience's attention is deliberately, sometimes audaciously, drawn to the artifice of the film's production. However, his visual style has always retained a sense of authenticity and naturalism. Even *Asteroid City* (2023), which is in some respects Wes's most 'artificial' live action feature film, uses natural light in the scenes set in the titular fictional desert town, which were shot on location in Chinchón, Spain.

Speaking to *Vanity Fair* in 2023, Wes's longtime cinematographer Robert Yeoman explained: 'Wes originally came to me, and he said his concept was to shoot everything in *Asteroid City* with natural light – so no movie lights.' The result is a film that contains more magic hour moments than any Wes film since *Bottle Rocket*.

Atmosphere and Mood

A story of madcap criminal endeavours in pursuit of escaping mundane American suburbia, *Bottle Rocket* follows the misadventures of three companions, Anthony, Dignan and Bob, played by brothers Luke and Owen Wilson and their real-life friend Robert Musgrave, respectively. From the outset, Wes establishes a visual language that relies heavily on natural light to convey atmosphere and mood.

The film opens with a shot of Anthony gazing out of a window from his room in a local mental institution, his face bathed in soft, diffused light. This initial image sets the tone for the film's exploration of the human condition, with Wes and Yeoman employing muted colours and subtle shadow to convey Anthony's state of mind.

Left: Anderson and cinematographer Robert Yeoman utilize natural light from the outset of *Bottle Rocket* (1996), as seen in this opening scene of the film, where Anthony (Luke Wilson) is distracted by a strange noise.

Bottle Rocket (1996)

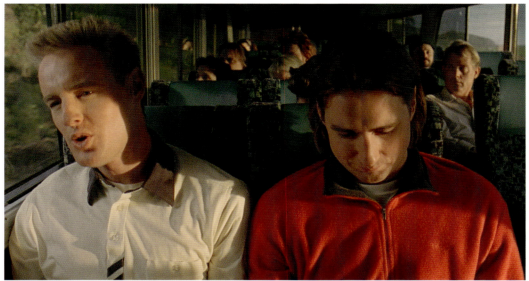

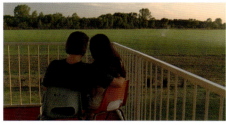

Top: Anthony and Dignan (Owen Wilson) are cast in natural light as they set out on what they hope will be a brighter path.

Bottom: Anthony and Inez (Lumi Cavazos) watch on from the motel terrace during magic hour as Dignan displays some titular pyrotechnics.

Golden Glow

In the next scene, after Dignan's plan to liberate Anthony from the institution has come to pass (one way or another), the pair are shown riding a bus together plotting their next scheme. Here the light is much more intense and is cast directly on the characters' faces, giving them a golden glow that symbolizes the promise of Dignan's ambitious 75-year plan. At this moment, the future looks decidedly bright for our foolhardy heroes.

Throughout the film, Wes uses natural light to accentuate the emotional states of his characters and underscore thematic motifs. One of the most striking examples of this is the frequent use of magic hour. Wes often captures his characters during these moments, imbuing scenes with a sense of nostalgia and longing.

When Anthony and motel cleaner Inez (Lumi Cavazos) share a tender moment on a rooftop, for example, Wes harnesses magic hour to heighten the romantic tension between them. As the sun dips below the horizon, we get the feeling that their connection may be as fleeting as the fading light, making Anthony's confession of love all the more poignant.

How to use natural light 23

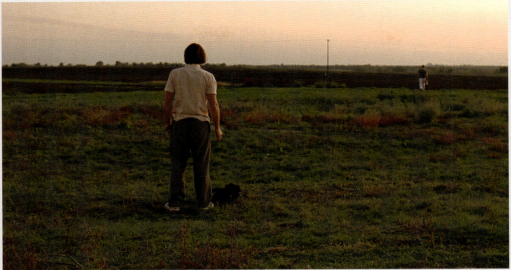

Top: After a heated argument, Dignan walks off into the distance as the camera lingers on a forlorn Anthony.

Bottom: The pair share a brief moment of reconciliation under a golden sky outside the penitentiary where Dignan winds up.

Sunrise, Sunset

Beyond its aesthetic appeal, Wes's use of natural light serves a narrative function, guiding the audience through the emotional arc of the story and the characters' often chaotic escapades. For instance, the scene where Anthony confronts Dignan over his reckless behaviour ends with the pair going their separate ways – yet while Dignan, ever the hero in his own mind, walks off into a dusky orange-pink sunset, the camera stays with Anthony as it dawns on him that the sun might be coming down on their friendship.

 Wes sets the final scene against a similar backdrop, creating a sense of visual cohesion. When Anthony, Dignan and Bob are briefly reunited in the grounds of the state penitentiary where Dignan has been sent following a botched robbery, Wes cuts to a wide shot of the trio sitting on a small row of bleachers that frames them beneath a golden sky. It's an optimistic, almost dreamlike moment, leaving us with the reassuring sense that even though these close friends are going to be apart for some time, everything will be all right in the end.

Bottle Rocket (1996)

PHOTO EXERCISE

SHOOTING AT MAGIC HOUR

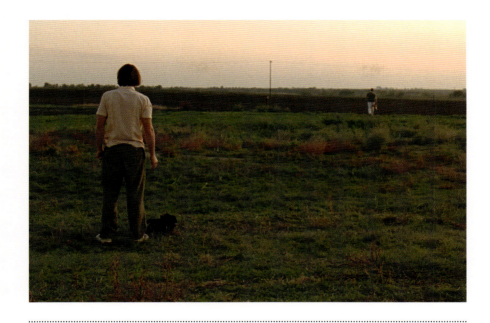

For this exercise, the aim is to capture an atmospheric shot of an individual subject, framed against a dusky exterior setting at magic hour.

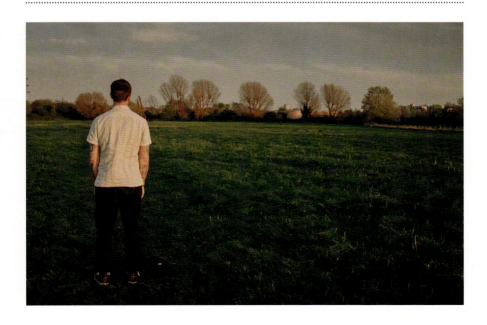

Bottle Rocket (1996)

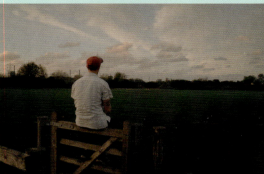

1 CHOOSE A SUITABLE LOCATION

Search for an outdoor location with an abundance of natural light, preferably a wide-open space such as a field or meadow that will allow you to capture as much of the sky as possible. You could try shooting your subject against a backdrop with interesting architectural features that align with Wes's aesthetic. Just make sure you are getting plenty of the sky in shot.

2 GET YOUR TIMING RIGHT

Your shooting window will be relatively small, so it's a good idea to arrive earlier than you need to. The light across golden hour changes: at its peak it will be harder, and when the sun is lower it will be softer. If it looks like the sun will be consistent from morning to evening, try shooting in the morning first so that you can redo the shot in the evening if needed. Just remember that the sun's position will be reversed at the end of the day.

3 COMPOSE YOUR SHOT

Consider the position of the sun relative to your subject in the frame. You'll want to shoot with the sun on your subject, and not into the sun. Shooting backlit achieves a dramatic effect, but it's not very Wes. Utilize the rule of thirds and leading lines, and play around with different angles until you are satisfied with the set-up. We made sure that our subject was fully in shot and that their head sat just above the horizon line so that it stood out against the sky; this is what the viewer's gaze will be drawn towards.

4 WAIT FOR THE RIGHT MOMENT

When you are happy with your composition, and confident that your subject is in focus, wait for moments when the light is at its warmest and the shadows are least harsh. If your subject is facing the sun, you can count them down to opening their eyes so that they aren't squinting when you press the shutter. Remember that a pose can communicate an emotion, even when only a person's back is visible.

5 BE REACTIVE

Be conscious of what the light is doing and react accordingly. Because the light changes very quickly and significantly during the magic hours, you may find that you need to regularly adjust your position – or that of your subject – and camera settings in order to make the most of the moment. Using natural light is a wonderful thing, but it's not the most forgiving, so try to not waste too much time faffing.

Top left: Stand behind your subject and adjust your position until you are happy with the framing and lighting.

Top right: This image displays the right quality of light but does not match the reference image from the film in terms of mood due to the conditions of the light.

Bottom: Mood-wise, this image is closer to the reference, but the scene is a bit too cluttered and therefore detracts from the main subject.

RUSHMORE (1998):

HOW TO USE COLOUR

Rushmore (1998)

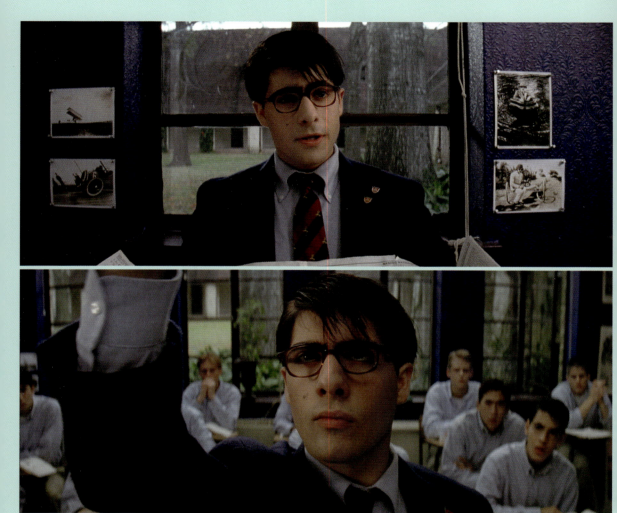

How to use colour 31

In Wes's vibrant cinematic universe, colour shapes not just the visual aesthetic but also the emotional language. The director's sophomore feature, *Rushmore* (1998), stands as a testament to this, with a colour palette of primary reds and blues helping to establish mood and express the varying emotions of the characters. Over the course of this ultimately life-affirming coming-of-age comedy-drama, Wes paints a visually arresting portrait of adolescence, ambition and the complex inner workings of human relationships.

From the opening frames of *Rushmore*, Wes immerses the audience in a world in which every hue and shade carries significance. The film's protagonist, Max Fischer (Jason Schwartzman), is introduced while lost in a daytime reverie. The preppy blazer that forms part of his school uniform is a deep navy, matching the colour of the wall behind him, while at the same time conveying certain characteristics such as intelligence and sensitivity – two qualities inherently associated with the colour. It is also striking that, in this dream, Max is the only member of his class shown wearing a blazer – an early indicator of the elevated opinion he holds of himself.

Colour Contrast

While Max immediately stands out at Rushmore Academy, it is telling that the place itself has a more subdued palette. As a bastion of tradition and order, the interiors of the fictional private school are dominated by beige and brown, evoking a sense of stuffiness and restraint. It's worth noting that the film was shot in and around Wes's hometown of Houston, Texas, and his own high school alma mater, St. John's School, was used as a stand in for Rushmore Academy. Any time Max finds himself in a situation where he has to try and win over members of Rushmore's faculty, the decor is invariably dark and oppressive.

Accordingly, Wes injects the film with splashes of colour to punctuate the drabness of Max's surroundings. One such instance occurs during the introduction of Rosemary Cross (Olivia Williams), who Max first locks eyes on while she is teaching a class of first graders. Max is shown peering through a window that is covered in pastel-shaded shapes, presumably cut out by the kids in Miss Cross's class, the framing serving to remind the audience that Max is really just a boy himself.

This is in contrast to the shock of royal blue that is used as a backdrop in the very next scene, which gives us the impression that Max has slipped back into a daydream state. For Max, Miss Cross's arrival not only disrupts the monotony of daily school life but also serves as a catalyst for his all-consuming sexual awakening, igniting a series of events that propel the narrative forward.

Left: Wes uses blue throughout *Rushmore* (1998), as in the opening classroom daydream sequence. The colour scheme of the classroom matches both Max's (Jason Schwartzman) outfit and emotional state.

Rushmore (1998)

Top: Max's meeting with the school's principal, Dr. Nelson Guggenheim (Brian Cox), is characterized by drab interior design.

Bottom: The same can be said for subsequent scenes where Max's ambition is curbed by dour-looking authority figures.

How to use colour 33

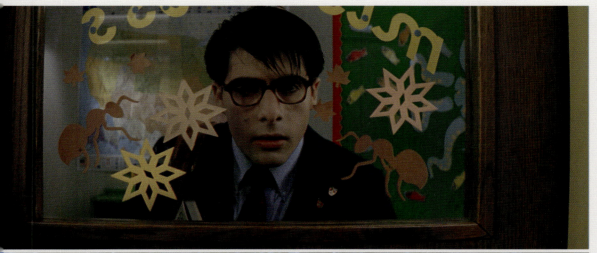

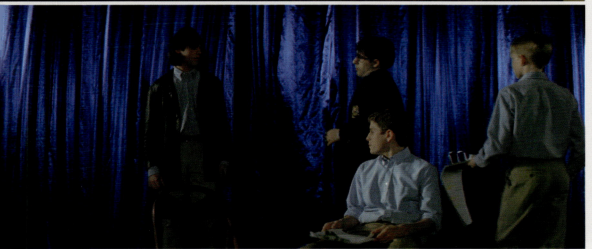

Top: Wes introduces softer, more childlike colours in the scene where Max first locks eyes on Miss Cross (Olivia Williams).

Bottom: The use of blue in this rehearsal scene again suggests that Max has entered a state of reverie.

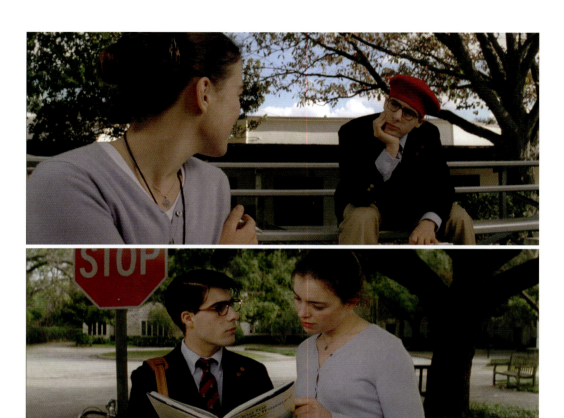

Top: During Max and Miss Cross's first conversation, Max wears a red beret, signalling his romantic intentions.

Bottom: The same colour appears prominently in a later scene in the form of a literal warning sign.

The Colour of Love

Soon after, Max engineers a formal introduction with Miss Cross on the bleachers overlooking the school playing field. To signal his intentions, Max embellishes his uniform with a bright red beret, a colour most commonly associated with passion and romance. She, on the other hand, is wearing a lilac cardigan – a softer blend of the blue and red worn by Max – indicating that her feelings towards him are as yet undetermined. It quickly becomes apparent that Max's crush on Miss Cross is not reciprocated, a point underlined later on through the unambiguous placement of a red stop sign.

How to use colour 35

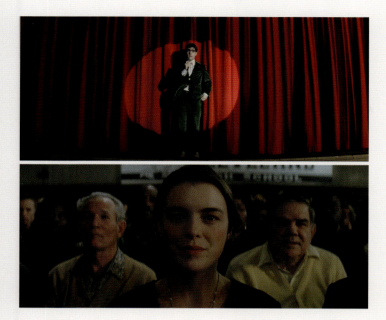

Top: Although red again dominates the frame during Max's introduction to his magnum opus, Wes wants us to pay attention to his green suit.

Bottom: In the same scene, a reaction shot of Miss Cross surrounded by men in yellow shows that her sometimes fraught relationship with Max has reached an amicable resolution.

Mellow Yellow

As the story unfolds, Wes uses colour to reflect the evolving dynamics between the central characters. A poignant example of this occurs during the climactic performance of Max's latest and most elaborate production, a Vietnam War-themed play titled 'Heaven and Hell', which he introduces standing in front of a crimson stage curtain wearing a green crushed velvet suit. Green implies new growth, so his attire suggests that Max has finally put his juvenile and highly inappropriate obsession with Miss Cross behind him.

Meanwhile, a reverse shot of Miss Cross shows her sitting in the audience flanked by two men in yellow, a subtle yet clear indication of the fact that she too is now in a much happier and more contented frame of mind.

Throughout *Rushmore*, Wes's use of colour extends beyond individual characters to encompass the broader thematic elements of the film. This is particularly apparent in the dull autumnal tones which are used to signal the passage of time and the inevitability of change. As Max navigates the tumultuous waters of adolescence, the seasons shift around him, mirroring his own journey of self-discovery and maturation.

Images of fallen leaves and overcast skies help to create an atmosphere of introspection, inviting us to reflect on the fleeting nature of youth. Wes may be renowned for his bold chromatic aesthetic, but in this case, it is the absence of colour that is most effective.

Rushmore (1998)

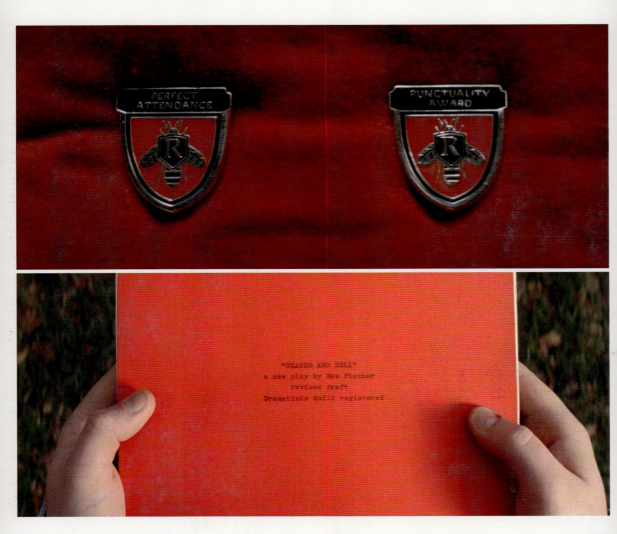

How to use colour 37

Red Redemption

In the aftermath of Max's expulsion from Rushmore, the film takes on an even more subdued palette, conveying his growing sense of isolation and disillusionment. Yet even amid the gloom of midwinter, Wes juxtaposes Max's mood with pops of colour, such as the Perfect Attendance and Punctuality Award pin badges Max presents to Herman Blume (Bill Murray), and the cover page of Max's script for 'Heaven and Hell', a copy of which he gives to school bully Magnus Buchan (Stephen McCole) with the offer of a starring role. In both cases, red represents not anger or conflict but having the courage and strength to make peace with an old adversary.

Rushmore is by no means the only Wes film in which specific colours take on symbolic meaning. Indeed, he often uses the same colours for the same purpose – like Max's red beret, Steve Zissou's red watch cap in *The Life Aquatic with Steve Zissou* (2004), Chas Tenenbaum's red tracksuit in *The Royal Tenenbaums* (2001) and the red Porsche inherited by the Whitman brothers from their late father in *The Darjeeling Limited* (2007) each represent masculinity and a paternal crisis of some form or another.

A less well-recognized aspect of Wes's signature aesthetic is the way he manipulates contrast and saturation during the grading process. Just as he likes to incorporate lots of pastel hues, where white is added to colours to soften their impact, he generally compresses the dynamic range of his images, meaning that the shadows, midtones and highlights are evenly balanced. As a result, even in scenes with predominantly muted tones, Wes ensures that there is enough saturation to keep the visuals engaging and vibrant, whether he's aiming for a dreamlike atmosphere or something more grounded and naturalistic.

Top: Red is the dominant colour in this shot of Max's merit badges, one of which he gifts to Herman Blume (Bill Murray).

Bottom: And again when Max placates Magnus Buchan (Stephen McCole) by offering him a part in his latest play.

Rushmore (1998)

PHOTO EXERCISE

COLOUR SCHEMING

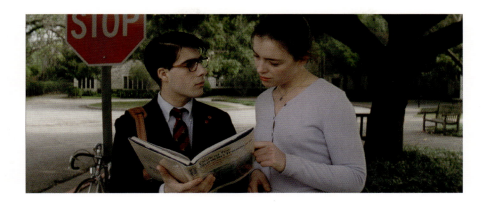

**The goal here is to shoot a portrait which leans into a colour
to emphasize a mood or message in a scene.
The colour should be worn by the subject and mirrored in the setting.**

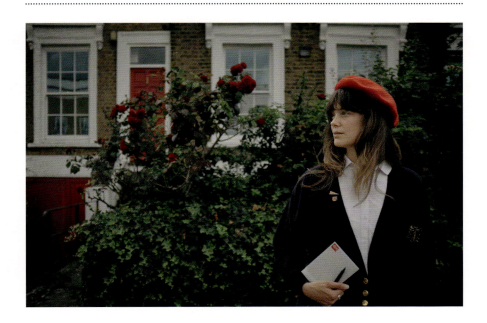

Rushmore (1998)

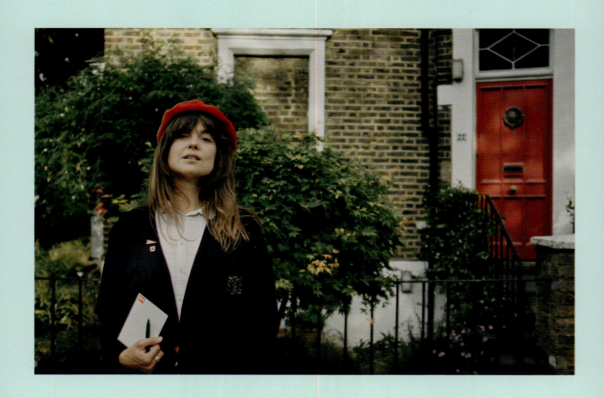

COLOUR WHEEL

Complementary colours lie directly opposite each other on the wheel. This will come in handy when choosing your accent and background colours.

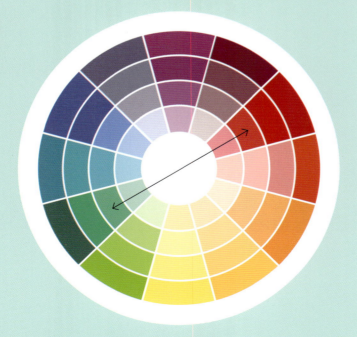

How to use colour

1. CHOOSE AN ACCENT COLOUR
Think about what mood or emotion you want your image to convey, then choose an appropriate colour. Reds and blues work well as accent highlight colours, both individually or together, as illustrated opposite, but it's worth playing around with non-primary colours too. You want the different iterations of the accent colour to be close to matching so the eye reads them almost simultaneously.

2. SELECT THE RIGHT GARMENT
Once you have chosen an accent colour, think about how best to incorporate it into your subject's outfit. We chose a red beret and made the rest of the outfit quite plain. Berets are synonymous with revolution, so they are an easy sell for someone who has a call to action. We added a letter with a red stamp to tie in with this narrative, as well as a red varsity pin badge alongside a university crest pin to communicate that this person is possibly a student.

3. PICK MATCHING BACKGROUND ELEMENTS
Look for one or two background elements that marry with your chosen garment to really sell the mood. Think carefully about the size: the elements should be large enough that they are clearly visible but not so big that they dominate the shot, taking attention away from the subject. Remember, the effect you are going for is naturalistic rather than overt.

4. COMPOSE YOUR SHOT
Position your subject within the frame so that they are close to a third line at either side of the image, and keep your camera level to them. The dominant background object should sit behind your subject, so that it catches the viewer's eye without being the main focal point. Make sure there are no other colourful objects or details within the frame that might compete with the background object or distract from your subject. Play with the aperture of the image (or with the blur filter on your camera phone) to find the sweet spot for focus, keeping your subject sharp and your background slightly blurred to give the image separation.

5. CHECK YOUR SHOTS
When you are happy with the composition, encourage your subject to get into character and try out a range of different expressions based on the narrative you are trying to portray. Pay close attention to the colours that you wish to highlight to ensure they effectively complement each other and convey the intended mood or message.

Top: The main background element (the red door) is slightly too prominent here, which makes the image feel overly composed and less natural. For the final shot, we used a backdrop with more subtle pops of red.

Bottom: The arrows indicate that red and green are opposites, and therefore stand out against each other. As you can see from the final shot, we applied the principle of pairing opposite colours (red and green) to create a visually appealing image.

THE ROYAL TENENBAUMS (2001):

HOW TO USE GOD'S-EYE VIEW

ALTERATION OF GLOVE

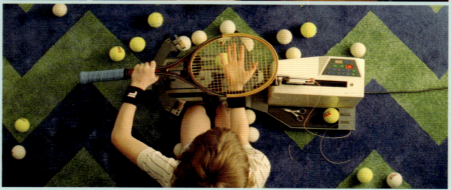

How to use God's-eye view

Various aspects of Wes's style have been developed throughout the course of his filmmaking career. However, his use of overhead shots, also known as God's-eye view, has been present right from the very start. Indeed, *Bottle Rocket* (1996) contains many such examples, to the extent that several contemporary reviews of Wes's film compared it with the work of one of his heroes, Martin Scorsese.

God's-eye view has become synonymous with Scorsese thanks to films such as *Mean Streets* (1973), *Taxi Driver* (1976) and *Goodfellas* (1990). Yet the fact that Wes has made this style of shot his own since the release of *Bottle Rocket* speaks to his masterful grasp of cinematic form and technique.

Higher Being

By placing the camera directly above his characters during moments of anger, ecstasy or spiritual transcendence, Scorsese invites the audience to contemplate the presence of a higher being – an all-seeing, all-knowing observer who is positioned to pass judgement on the morally compromised antiheroes that populate his films. Although Wes tends to use God's-eye view in a slightly less objective way, there is one particular shot in Wes's 2001 film *The Royal Tenenbaums* that is pure Scorsese.

The scene where unscrupulous patriarch Royal (Gene Hackman) fakes a heart attack in front of his family features a shot which appears to mimic the divine perspective found in Scorsese's films. But given the context, this can be read as Wes subverting the audience's expectations of how and why God's-eye view is used: Royal isn't really suffering, and so there is no deeper meaning and certainly no spiritual catharsis taking place here.

Wes underlines this point with a great punchline delivered via a first-person point-of-view shot (a technique you can read more about in Chapter 9), revealing a message received by Royal's friend Dusty (Seymour Cassel) on his pager, who is standing a few feet away having been roped into playing a doctor to further sell the charade.

Aerial Artistry

Whenever Wes uses God's-eye view, he does so to draw our attention to a vital piece of information concerning the characters or the plot. During the prologue to *The Royal Tenenbaums*, for example, we catch an early glimpse of the rarefied lives of the three young Tenenbaum children through a series of overhead shots as the narrator (voiced by Alec Baldwin) reels off their list of prodigious accomplishments while simultaneously establishing the root of their dysfunctional relationship with their parents, Royal and Etheline (Anjelica Huston), not to mention each other.

Carefully matched to the narration, each God's-eye view shot in this sequence tells us something about each character's personality or backstory, be it Chas's (Ben Stiller) drive to succeed, Margot's (Gwyneth Paltrow) sense of detachment from the rest of the family (which stems from the fact that she was adopted at age two), or Richie's (Luke Wilson)

Top: Royal Tenenbaum (Gene Hackman) fakes a cardiac arrest, as captured from a God's-eye view perspective.

Bottom: Three more examples of God's-eye view in *The Royal Tenenbaums* (2001), introducing us to the film's maladjusted sibling protagonists.

The Royal Tenenbaums (2001)

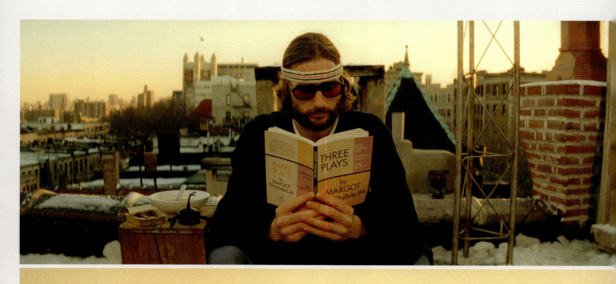

Top: Wes plays with perspective throughout the film, neatly cutting from Richie Tenenbaum (Luke Wilson) reading a book of Margot's (Gwyneth Paltrow) plays...

Bottom: ...to a chapter page in the eponymous print edition of the very film we are watching.

somewhat scattered mental state, all of which inform our basic understanding of the characters and their complicated lives.

The manner in which Wes uses God's-eye view in *The Royal Tenenbaums* also serves as a commentary on the nature of narrative storytelling. By dividing the film into chapters and beginning each one with a visual callback to the library book shown during the opening credits, which bears the same title as the film, Wes invites the audience to question the reliability of the story that is being presented to us – or, at the very least, whose perspective it is being told from.

There is even a moment when Richie is shown reading a book of collected plays by Margot right before a title card announcing the start of Chapter Three appears on screen, framed in extreme close-up as though it is being viewed from above by someone other than the audience. If nothing else, this recurring motif reinforces the notion of *The Royal Tenenbaums* as an elaborately constructed metanarrative – a story within a story within a story.

Doomed Romance

Margot and Richie's quasi-incestuous relationship sits at the film's emotional core, and it is telling that Wes uses God's-eye view once again in the scene where they confess their love for one another following Richie's attempted suicide, before accepting that they are destined not to be together ('*I think we're just gonna have to be secretly in love with each other and leave it at that, Richie*'). There is arguably no more affecting sight in the film than that of these adopted siblings tenderly embracing in Richie's childhood tent, in a bedroom that has been preserved like a shrine to their doomed romance.

Overhead Empathy

Later, Chas experiences his own moments of heartfelt reconciliation with other characters: first when he lays down next to Eli Cash (Owen Wilson) following their fight at the Tenenbaum house, which momentarily disrupts Etheline's wedding to Henry Sherman (Danny Glover); and second when Royal suffers a genuine cardiac arrest while riding a garbage truck in an echo of an earlier scene, with Chas comforting his dying father in the ambulance en route to the hospital.

In each case, Wes frames the scene from above so as to bring the characters closer together in both a physical and spiritual sense, their proximity reflecting the sudden and profound sense of compassion and empathy they feel for each other.

The Royal Tenenbaums (2001)

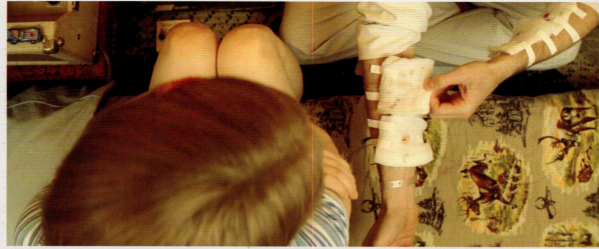

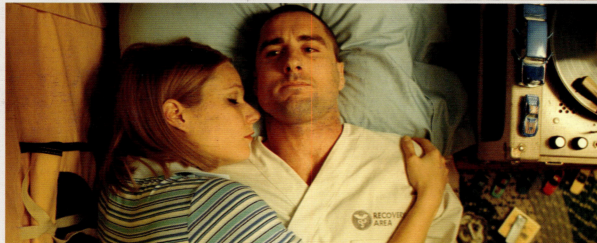

Top: Wes employs God's-eye view to poignant effect when Margot and Richie confess their mutual attraction.

Bottom: The technique is used throughout the scene, placing the viewer in an elevated position to create empathy with the characters.

How to use God's-eye view 49

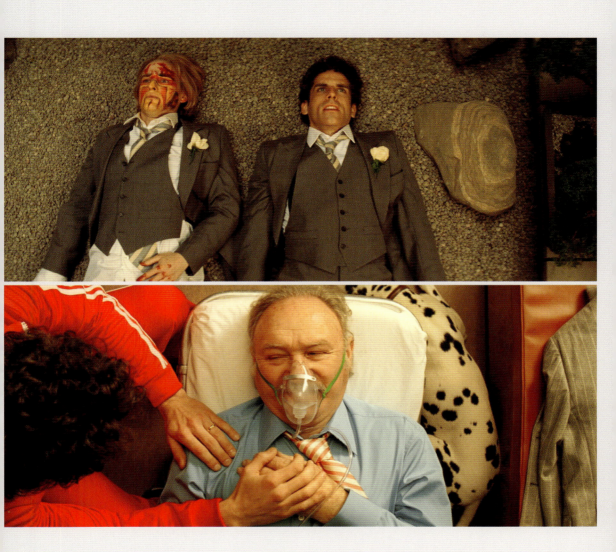

Top: God's-eye view is typically used during moments of calm, like when Chas Tenenbaum (Ben Stiller) and Eli Cash (Owen Wilson) rest following a brief scuffle.

Bottom: Royal suffers a heart attack for real, with Wes utilizing God's-eye view as a callback to an earlier scene (see page 44, top).

The Royal Tenenbaums (2001)

PHOTO EXERCISE

SHOOTING FROM ABOVE

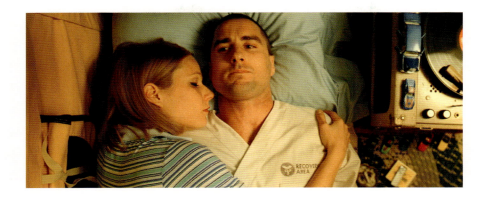

This exercise requires you to gain a safe vantage point directly above your subject(s) in order to capture a God's-eye view perspective.

The Royal Tenenbaums (2001)

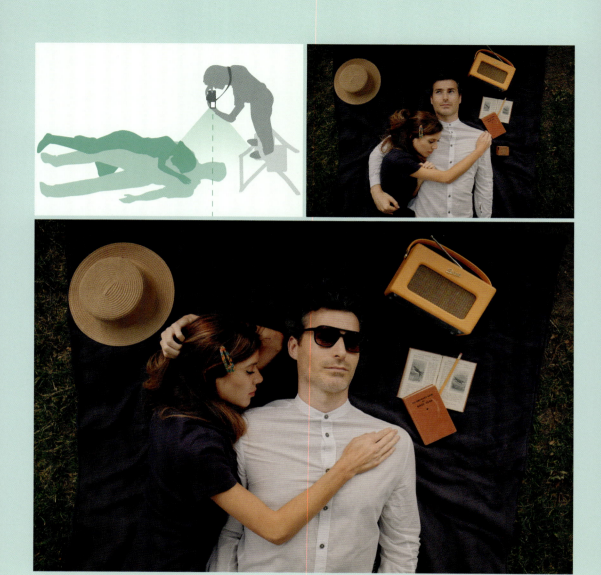

1 CHOOSE A SUITABLE LOCATION

Find somewhere where your subjects can lie comfortably that also allows you to stand over them. For safety, make sure the area is flat. Consider outdoor locations with natural textures like grass, or an indoor setting with a clean, uncluttered floor. We settled on a local park with picnic benches, and chose to shoot at a time of day when we knew it would be relatively quiet. Ensure the area is safe and easily accessible both for you and your subjects.

2 POSITION YOUR SUBJECTS COMFORTABLY

Have your subjects, in this case a couple, lie down or position themselves on the ground comfortably. They can be side by side, head to head, or in a pose that shows their connection, such as holding hands or embracing. It may take you a bit of time setting up the shot and adjusting your subjects, so make sure you have a cushion or something soft to hand so they stay comfortable and relaxed.

3 ELEVATE YOURSELF SAFELY

A solid structure such as a bench will provide a sturdy surface on which to stand, and should give you enough height and distance from your subjects. Unless you are using a particularly wide lens, simply standing over them will not suffice. Depending on where you are shooting, you could also use a step ladder or an elevated platform to get a clear overhead shot. Ensure that you are holding your camera securely and use a strap if you have one. Don't lean too far over, as this may hinder your shot and could be dangerous.

4 FRAME THOUGHTFULLY

Frame your subjects in the centre of the shot, ensuring that the background and any props you are using complement the narrative you are trying to build and the overall composition, rather than distracting from it. Use props sparingly for these shots, as they should be communicating emotion rather than establishing setting. Experiment with both symmetrical and asymmetrical arrangements to find the most appealing composition.

5 CAPTURE AND REFINE

Take multiple shots to capture a variety of poses and expressions. Encourage your subjects to relax and interact naturally. If you are shooting on a digital camera or camera phone, review your images as you go and make any necessary adjustments to angles or poses. You can use post-processing tools to enhance colours, correct exposure and remove any distracting elements, but it's best to capture as much in-camera as possible.

Top left: Position yourself directly above your subject(s) so that you are able to comfortably point your camera straight down at them.

Top right: Uncropped, there is too much space around the subjects, resulting in an image that lacks intimacy compared to the reference.

Bottom: This shows how the addition of a prop or piece of costume (in this case sunglasses, which hide the subject's emotions) can drastically alter the mood of the scene.

THE LIFE AQUATIC WITH STEVE ZISSOU (2004):

HOW TO WIDEN YOUR FRAME

The Life Aquatic with Steve Zissou (2004)

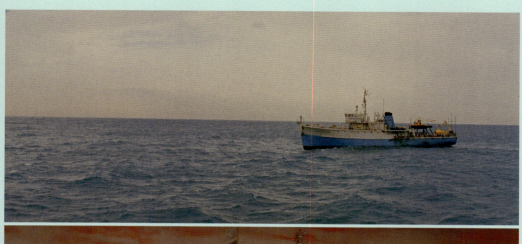

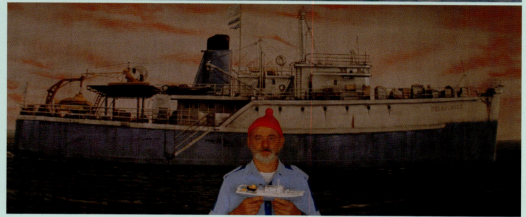

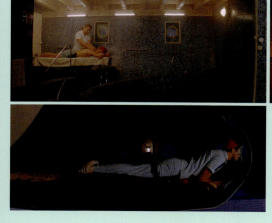

How to widen your frame

Wide-angle shots are a staple of Wes's cinematic toolkit, with regular director of photography Robert Yeoman frequently utilizing anamorphic lenses to create a deep depth of field or capture multiple subjects against panoramic backdrops. Given that much of the action in *The Life Aquatic with Steve Zissou* (2004) takes place at sea, it stands to reason that Wes would make extensive use of wide-angle shots throughout the film to capture the expanse of the open ocean.

Zissou's World

One function of widescreen framing in *The Life Aquatic* is to establish the world in which the film's seafaring protagonist operates. The plot loosely concerns Zissou (Bill Murray) leading his ramshackle crew on a dangerous revenge mission aboard his trusty research vessel, the *Belafonte*. As such, there are numerous wide-angle shots of the ship in its natural habitat, navigating the open ocean in search of the rare killer jaguar shark that ate Zissou's close friend and colleague, Esteban du Plantier (Seymour Cassel), on a previous expedition.

Yet Wes's use of wide-angle lenses extends far beyond mere spectacle. The expansive frame also helps to accentuate Zissou's larger-than-life persona, not to mention the idiosyncrasies of his crew. As the camera pans over a cross-section of the ship during a guided tour led by Zissou, we are introduced to a colourful cast of characters, each occupying their own space within the frame.

This composition highlights the ensemble nature of the film while allowing individual personalities to shine through. Each time the camera arrives in a new compartment, it lingers for a moment to enable the audience to take in information about the characters, as well as to admire the craft of the full-scale model of the *Belafonte* which Wes had specially built for this sequence.

Visual Humour

Wes also uses wide-angle shots to enhance the interactions between characters, often in comedic or dramatic moments. In one memorable scene, Zissou is interviewed in the ship's science lab by Jane Winslett-Richardson (Cate Blanchett), a reporter from *Oceanographic Explorer* magazine, and Wes showcases his penchant for visual comedy by having an orca, which resides at Zissou's compound, repeatedly swim past Zissou in the background of the shot. When Zissou pulls a Glock on Jane, pointedly asking her, 'Does this seem fake?' (a moment apparently improvised by Murray), the orca turns its head to face the action, as if anxious to see what will happen next. Earlier in the film, Zissou is shown feeding the same orca in an impressive wide-angle shot that gives a true sense of the scale of the stunt that is being performed.

Contrary to its many comedic moments, *The Life Aquatic* also explores themes of loss, redemption and existential crisis. Wes skilfully harnesses the power of wide-angle cinematography to convey the emotional depth of his characters, particularly Zissou. In moments of vulnerability, such as when

Top: Wes utilizes wide camera angles to great effect in *The Life Aquatic with Steve Zissou* (2004), here capturing the *Belafonte* in all its glory.

Middle: Steve Zissou (Bill Murray) stands in front of a painted backdrop depicting his ship, framed in a wide-angle shot in order to capture every detail.

Bottom: Wes uses wide angles to show off the ship's interiors, including the on-board sauna, research library and observation bubble.

The Life Aquatic with Steve Zissou (2004)

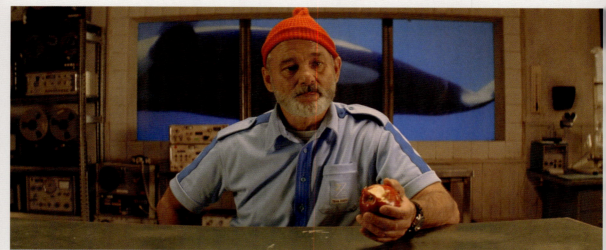

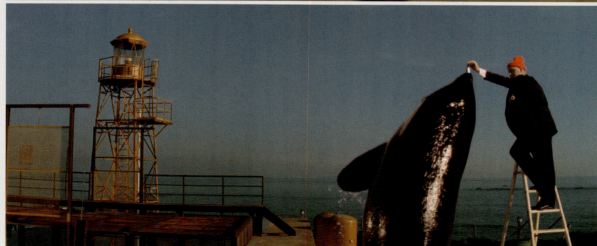

Zissou stands at the end of a jetty reflecting on the death of Esteban, the wide-angle serves to emphasize his solitude against the vastness of the ocean – a neat visual metaphor for Zissou's internal turmoil.

Later, following a tragic helicopter accident, Zissou carries the lifeless body of his long-lost son Ned (Owen Wilson) out of the water in a dramatic shot laced with religious overtones. In both instances, Wes's choice of framing is intended to evoke empathy and understanding from the audience, encouraging us to reflect on the complexities of the human experience and, most pertinently, the isolation of the film's protagonist.

Spatial Awareness

It is also worth considering how Wes uses wide-angle framing to create a consistent sense of space throughout the film, particularly in scenes that take place within the confines of the *Belafonte*. Being set largely on a boat, there are naturally lots of moments in the film where the frame is populated by multiple characters at the same time. In these instances, a wider perspective helps to reduce the feeling of claustrophobia that arises from the chaos of the action or the tightness of the space.

This is best exemplified when Ned is treated after being struck on the head by one of the Filipino pirates who attack the ship after it sails into unprotected waters. And again, towards the end of the film, when Zissou shares a moment of introspection, and ultimately acceptance, with his crew upon coming face to face with the jaguar shark.

This is the emotional climax of the film, but crucially Wes opts not to shoot it in close-up as might be expected. Instead, he carefully blocks the actors (meaning to establish their positioning and movements in relation to the camera) within the cramped submersible setting so that each character is clearly visible and consequently the camaraderie and collective catharsis among Team Zissou is keenly felt. So, while wide-angle shots can be a convenient and economical way of delivering lots of expositional detail or creating a sense of scale and grandeur, they are also great for conveying intimacy.

Top: Here, the wide-angle interior shot is used for comedic effect, as an orca swims past the ship while Zissou is being interviewed by Jane Winslett-Richardson (Cate Blanchett).

Bottom: The same killer whale performs an impressive aerial trick, leaping from the water to take a fish from Zissou's hand.

The Life Aquatic with Steve Zissou (2004)

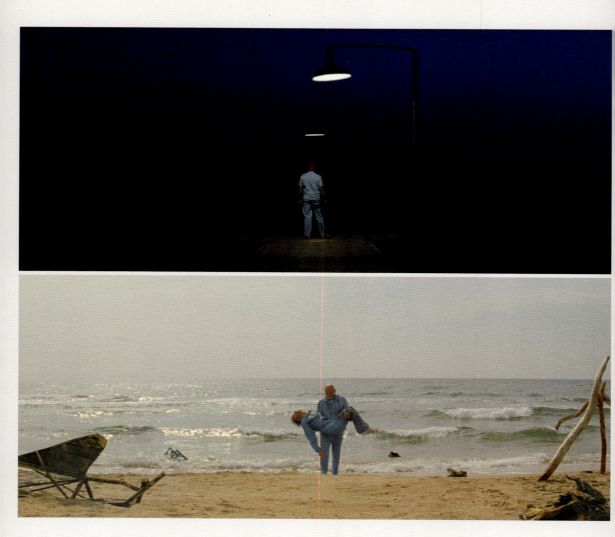

Top: Wide-angle compositions can be used to great dramatic effect, as in this example of Zissou standing at the end of a jetty at dusk.

Bottom: And again, when Zissou carries the body of his estranged son Ned (Owen Wilson) onto the beach following their helicopter crash.

How to widen your frame 61

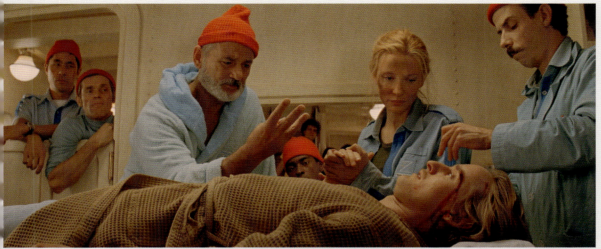

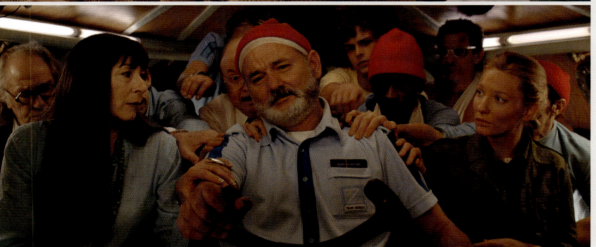

Top: Shooting with a wide-angle lens is also a great way of getting more emotional detail into a shot, as in this moment on board the *Belafonte*.

Bottom: Wes uses a different kind of wide-angle shot to capture the entire crew's reaction to Zissou's cathartic reunion with the jaguar shark.

PHOTO EXERCISE

DEEP FOCUS

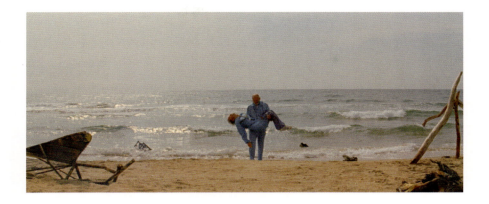

This exercise is all about creating a symmetrical composition where a single subject stands out against a striking backdrop, with both in focus.

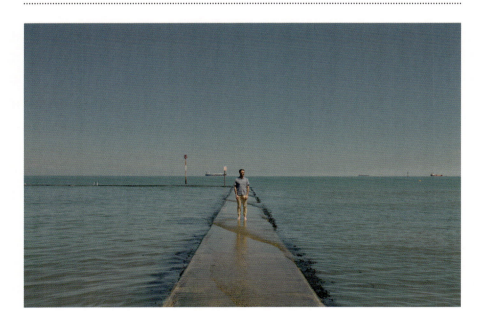

64　The Life Aquatic with Steve Zissou (2004)

The red-and-white pole in the background is almost in line with our subject, making the image feel like it is being carved in half, with our subject trapped on a tightrope in the centre.

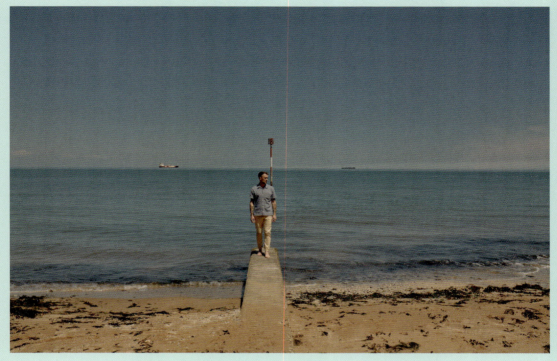

Crucially, the concrete walkway is much shorter, meaning our subject is closer to the camera and thus feels less isolated. Secondly, it means that the image lacks depth.

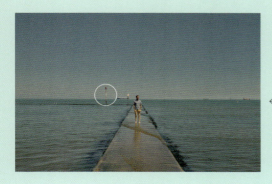

Here, the walkway is much longer and the subject is further from the camera, giving the image more depth.

How to widen your frame

1 CHOOSE AN EXPANSIVE BACKDROP
Find a location that has a visually interesting background and a relatively flat horizon line, such as a shoreline or an open plane. Ensure the backdrop has strong lines or features that will enhance the symmetry of the image. Shoot during a time of day that will give you even lighting so that both your subject and the background look their best. Remember that you want both your subject and the background to be in focus.

2 FIND A WIDE ANGLE
Ideally for this type of shot a wide-angle lens would be used. This will allow you to comfortably fit both your subject and the backdrop in the frame. However, if you don't have an arsenal of lenses at your disposal, you can always reposition yourself. Establish a mark on which to set your subject and move away from that point until they appear at the desired scale within the frame.

3 CENTRE YOUR SUBJECT
Position your subject in the centre of the frame to emphasize symmetry. Then make sure you are directly in line with them to maintain compositional balance. Ensure the horizon line is level in your camera's viewfinder and positioned close to the middle of the frame. Your subject's head should be above the horizon line.

4 CHECK YOUR COMPOSITION
If your camera has grid lines, turn them on: they will help you line up all the elements of the shot. Take a few test shots and review them for symmetry and focus. Make adjustments to the position of your subject or your camera angle if needed. Employing a one-point perspective will help. When shooting wide, small changes can significantly impact the balance and overall appeal of the image, so keep tweaking the position of the elements until you get the composition right.

5 COMMUNICATE CLEARLY
Bear in mind that when you are distanced from your subject, it will be harder to direct them on how you would like them to move. This exercise relies on good communication, so before you begin setting up the shot, ensure your subject is briefed on what mood their pose is intended to evoke. Remember that this is essentially a landscape shot with a human element, so small gestures and facial expressions are less important here than in tighter shots. It's all about creating a dramatic image by incorporating as much of the background scenery as possible.

Top: This is a less successful option we shot for this exercise. It doesn't work quite as well for a number of reasons.

Bottom: The more successful composition.

THE DARJEELING LIMITED (2007):

HOW TO SHOOT GROUP PORTRAITS

The Darjeeling Limited (2007)

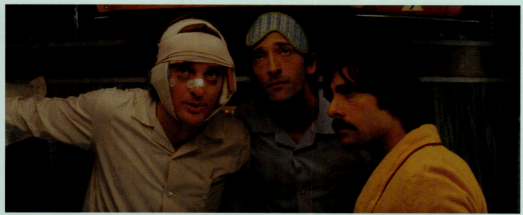

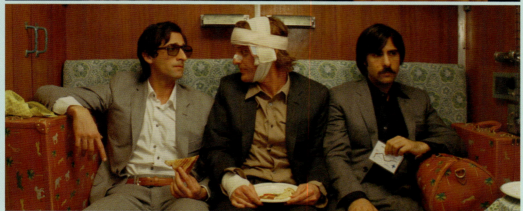

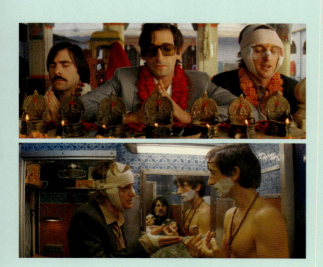

How to shoot group portraits 69

Wes's signature style takes on a new dimension in *The Darjeeling Limited* (2007) as he explores themes of brotherhood, identity and belonging against a colourful and chaotic backdrop. Central to Wes's visual storytelling in this film is his distinctive approach to shooting group portraits, a technique that serves as a lens through which to examine the dynamics of family and the intricacies of human connection. Here, as in Wes's other films, group portraits are characterized first and foremost by the spatial relationship between the actors/characters.

Early in the film we are introduced to the Whitman brothers – Francis (Owen Wilson), Jack (Jason Schwartzman) and Peter (Adrien Brody) – through a series of static images that emphasize their unity while hinting at underlying tensions between them. As they embark on a spiritual journey across India aboard the Darjeeling Limited, almost exactly one year after the death of their father, the sight of the brothers sharing a single frame becomes a recurring motif, adding depth to the story while capturing moments of harmony and discord within this fractured fraternal unit.

Shoulder to Shoulder

One of the most striking examples of a group portrait in *The Darjeeling Limited* occurs when the brothers disembark the titular train to explore a rural village. After scouring a local market for shoes and a power adapter, they make their way to a temple and assume a customary kneeling prayer position in front of a shrine. Wes places the brothers behind an evenly spaced row of candles, the symmetrical, shoulder-to-shoulder staging suggesting that they are all reading from the same scripture, metaphorically speaking. Yet it is Peter who dominates the frame, perhaps implying that he is more affected by their father's death than Francis and Jack.

Just as symmetry can create a sense of solidarity, asymmetry can elicit a sense of confusion or disharmony. In another pivotal scene, Francis and Peter get into a heated argument after Francis notices that Peter is shaving with their dad's razor. A petty sibling skirmish ensues, which ends with Jack macing the pair of them. But initially, Wes frames the trio using a mirror to reflect their strained relationship in this moment. While Francis and Peter occupy the foreground of the image, Jack is positioned behind the camera so that he appears to be caught in the middle. This notion is further enforced by the fact that while he is partaking in the same activity as Peter, his attire places him more on Francis's side.

Top: Early on in *The Darjeeling Limited* (2007), Wes often frames the Whitman brothers in close proximity to underscore their sibling bond.

Middle: Peter (Adrien Brody), Francis (Owen Wilson) and Jack (Jason Schwartzman) sit side by side as they begin their journey across Northern India.

Bottom upper: In this group shot, Wes adds a row of prayer candles in the foreground to frame the brothers and enhance the scene's symmetry.

Bottom lower: Meanwhile, asymmetry is used to great effect in the scene where Francis confronts Peter over his claim to their late father's razor, with a minimized Jack appearing between them in the reflection of a bathroom mirror.

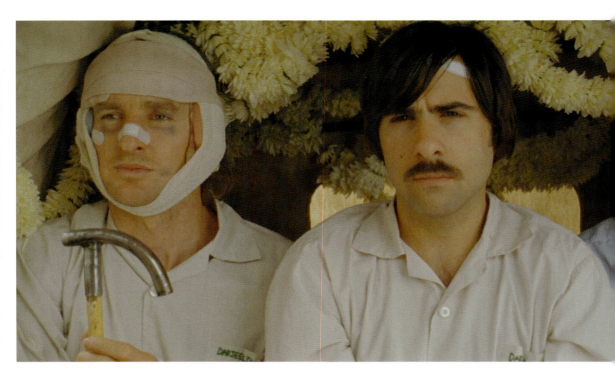

Match Cut

Throughout *The Darjeeling Limited*, Wes utilizes group compositions to capture the brothers' shifting power dynamic and fluctuating emotions. At one point, he even uses a match cut (an editing technique where two consecutive shots are linked by a visual element that maintains continuity) to jump back in time to show the brothers preparing for their father's funeral. It's a highly effective transition that reinforces the idea that, despite their differences, there remains a sense of underlying affection and attachment between Francis, Jack and Peter – even at their lowest emotional ebb. In this instance, Jack is again positioned in between Francis and Peter, but rather than being minimized, he is given equal status.

Perhaps the most poignant group shot in the film arrives when the brothers attend the funeral of a young boy who drowned in a river while attempting to cross it with two other boys. We see the incident take place right in front of the Whitmans: although Francis and Jack manage to rescue two of the boys, Peter is unable to save the third. Understandably, Peter's guilt is intensified, as indicated by the space between him and his brothers, whose bond appears to have been strengthened by the experience.

How to shoot group portraits 71

Left: The brothers' shared trauma is emphasized throughout the film in intimate group portraits such as this, which occurs during the young local boy's funeral.

Personal Growth

Immediately after the boy's funeral, the brothers travel back into town by bus. Here they seem more relaxed, each wearing a serene expression that suggests they have now entered the final stage of grief. Wes frames them even tighter than before – they are literally overlapping – and has them facing the same direction to emphasize their closeness. At the end of the film, with Francis, Jack and Peter having discarded their father's luggage before hopping on a new train to continue their adventure, Wes brings the film's central theme full circle as the brothers forge ahead on the path to personal growth and recovery.

Tableau Aesthetic

Over the course of his filmmaking career, Wes has perfected the art of the group portrait, developing a method of arranging multiple actors within the same space and positioning them front-on to the audience to create an effect akin to a three-dimensional painting or photograph. These tableau-style compositions are as versatile (Wes doesn't just use them for group shots) as they are aesthetically pleasing, and their static nature allows the audience to absorb crucial information and symbolic elements more easily. In short, it is always worth paying attention to precisely how and when Wes uses them.

The Darjeeling Limited (2007)

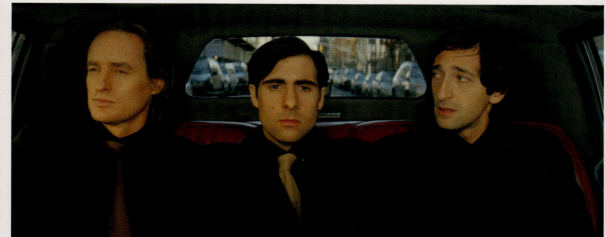

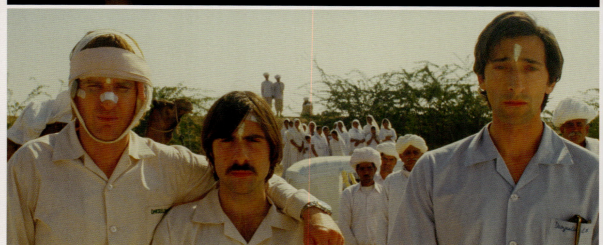

Top: In a flashback to their own father's funeral, Francis, Jack and Peter appear at odds with each other.

Bottom: Wes uses a match cut to bring us back to the present timeline, adding space to heighten the sense of disharmony among the trio.

How to shoot group portraits 73

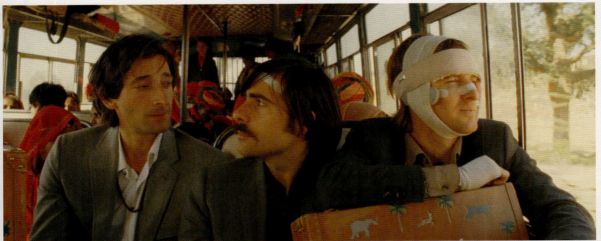

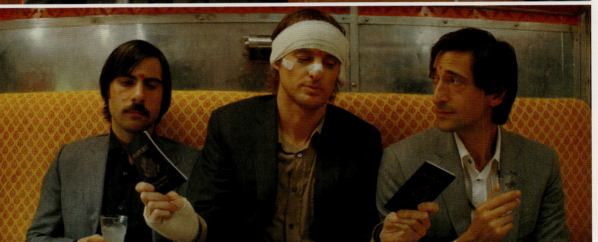

Top: In contrast, the Whitmans seem far more content in each other's company as they continue their journey via bus.

Bottom: At the end of the film, Wes uses a final group portrait to bookend the brothers' journey, with all three having reached a point of catharsis.

The Darjeeling Limited (2007)

PHOTO EXERCISE

SHOOTING A GROUP

Beyond fitting multiple people into the same frame, the main idea here is to try to capture the moods and personalities of your subjects, as well as their relationship to each other.

1. CREATE A BACKSTORY
When shooting groups, it sometimes helps if your subjects already know each other. But if you don't happen to know a trio of real-life siblings, it doesn't matter – the trick with this exercise is to create a backstory that will enable your subjects to get into character. Think about the emotions and feelings you want your subjects to express, either collectively or individually.

2. PLAN YOUR WARDROBE
If you want to create a sense of harmony between your subjects, your best bet is to dress them in coordinated outfits, preferably smart-casual dress that has a vintage aesthetic à la Wes. The outfits don't have to be matching, but they should share certain colours, patterns or textures. It's also a good idea to adorn each of your subjects with one or two personal accessories to convey their individual sense of style and character.

3. POSITION SYMMETRICALLY
Arrange your subjects in an even, symmetrical composition. Consider having them stand in a straight line or sit in a slightly overlapping formation to create a sense of closeness. Placing your subjects in close physical proximity will help create a feeling of emotional connection, while conversely, leaving a gap between them will create a feeling of emotional distance. If you want to achieve a more formal look, have them face the camera with minimal variation in posture and movement.

4. AVOID DRAMATIC EXPRESSIONS
Pay attention to small details such as matching body language or synchronized poses to create uniformity and quirkiness. Ask your subjects to adopt either neutral or subtle facial expressions, avoiding overly emotional or dramatic expressions to emulate the intimate and introspective nature of Wes's style. Give your subjects clear and simple instructions, and encourage natural interactions that reflect their connection and intimacy.

5. KEEP IT UNCLUTTERED
Consider the negative space around your subjects. In Wes's films, groups of characters are generally framed in such a way that the viewer's attention is instantly drawn to them. It's fine to include a few props or visually interesting background elements, but first and foremost you want to arrange the space around your subjects so that it doesn't distract from their individual expressions and the group dynamic.

Top: This image works compositionally but is less visually exciting. Inside the taxi, the subjects feel more confined, accentuating the desired mood.

Bottom: The spacing between the subjects here results in a more informal composition and a lack of tension, which gives the scene a more joyful mood.

FANTASTIC MR. FOX (2009):

HOW TO USE LOW-ANGLE SHOTS

Static camera placement and head-on shot composition are well-established hallmarks of Wes's style. Yet although the director has a clear preference for shooting actors at eye level in the centre of the frame, he also makes frequent use of low-angle shots, sometimes to an extreme degree. In *Fantastic Mr. Fox* **(2009), for example, Wes often positions the camera below eye level and points it up to imbue his characters with a sense of authority, power or vulnerability, depending on the context of the scene.**

A prime example of this can be found in scenes where Mr. Fox (voiced by George Clooney) encounters his arch nemeses, Boggis (Robin Hurlstone), Bunce (Hugo Guinness) and Bean (Michael Gambon). As Mr. Fox devises increasingly elaborate schemes to outwit his adversaries and reclaim his freedom, the camera often adopts a low angle, framing the three farmers as imposing, almost insurmountable obstacles. During the 'Terrible Tractors' sequence, the way Wes frames the mechanical diggers operated by Boggis, Bunce and Bean as they hurtle towards the Foxes' home makes them appear like snarling beasts.

Forced Perspective

This visual representation of the farmers' power serves to underscore the enormity of the challenge facing Mr. Fox and the other animals, highlighting the stakes of their struggle for survival. Likewise, when Mr. Fox first faces off against the devious Rat (Willem Dafoe) in Bean's cider cellar, the low-angle framing creates a distorted or 'forced' perspective which makes Rat seem even more menacing, drawing attention to his red eyes, sharp teeth and the switchblade he is brandishing. Wes repeats the trick later on when Mr. Fox and Rat clash again in the sewer. In both cases, the sense of jeopardy is heightened simply by tilting the camera upwards at the subject.

Wes also uses low-angle framing in the film to create the opposite effect and elevate his protagonist. In several key scenes, Mr. Fox's stature and confidence are accentuated through low-angle shots, positioning him as an important figure within the world of the film. When Mr. Fox throws a dinner party for his furry comrades, he is first shown from the seated point of view of Badger (Bill Murray) at the far end of the table, giving the scene an instant sense of ceremony and grandeur. When Mr. Fox rises to address his guests, Wes cuts in closer to emphasize his high ranking among the group.

Hero Shots

Taking this idea even further, the use of low-angle shots in moments of triumph or defiance reinforces the film's underlying message of resilience and perseverance in the face of adversity. This is best illustrated in the lead up to the film's climactic showdown, when Mr. Fox and his allies band together to enact 'Master Plan B' in response to the farmers' latest onslaught, striding purposefully like the Magnificent Seven. And again, when Ash (Jason Schwartzman) assumes the guise of the white-caped comic-book hero he idolizes.

Top and Middle: In *Fantastic Mr Fox* (2009), Wes frames our hero's adversary, Rat (Willem Dafoe), from a low angle, enhancing his menacing presence.

Bottom left: When farmers Boggis, Bunce and Bean (Robin Hurlstone, Hugo Guinness, Michael Gambon) plot Mr. Fox's demise, the framing suggests they mean business.

Bottom right: Similarly framed, the farmers roar towards Mr. Fox's den, this time aboard their 'terrible' tractors.

Fantastic Mr. Fox (2009)

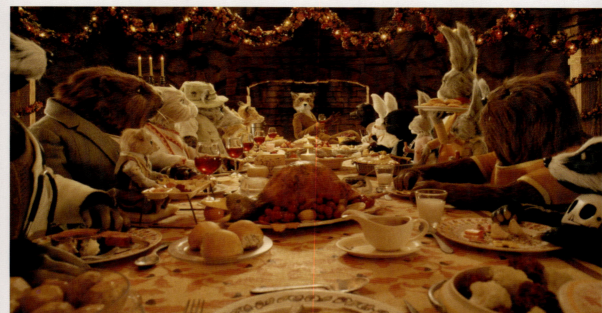

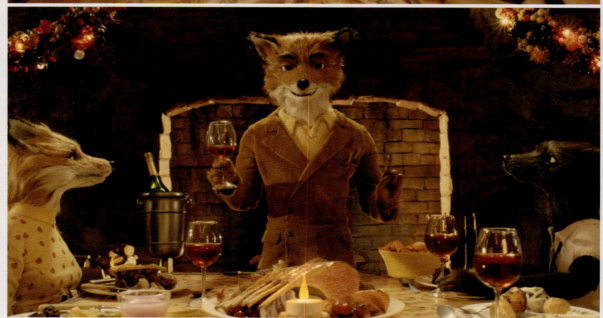

Top: In a light-hearted moment, Wes frames the film's protagonist from the perspective of one of his peers, looking down the length of a dining table.

Bottom: In a more tightly framed low-angle shot, Mr. Fox makes an impassioned speech to boost the spirits of his motley crew.

How to use low-angle shots 83

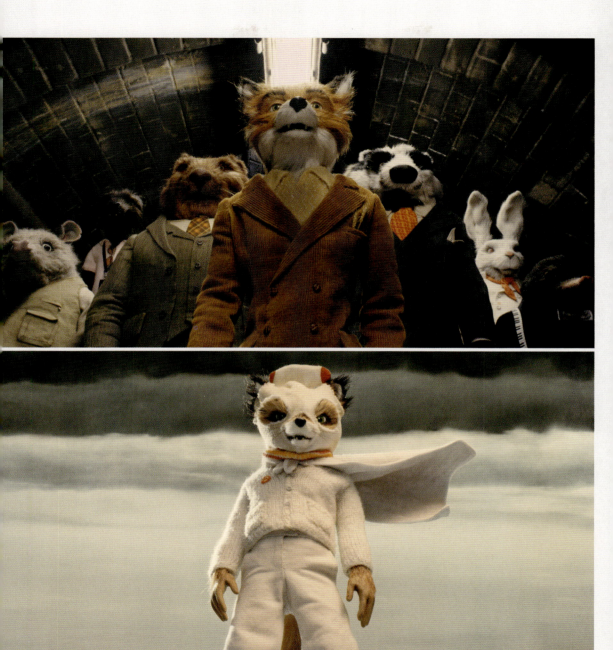

Top: Pointing the camera up at a subject can cast them in a heroic light, as in this shot of Mr. Fox and co. striding through the sewer.

Bottom: In a similar hero shot, young Ash (Jason Schwartzman) assumes the guise of his comic-book idol, White-Cape.

Fantastic Mr. Fox (2009)

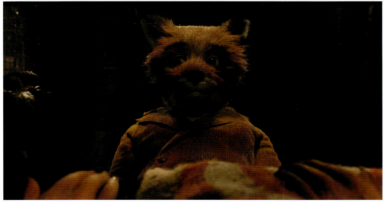

Top: In a sort of reverse God's-eye view shot, Wes captures the touching moment when Mr. Fox laments the death of Rat.

Bottom: Moments later, Wes employs a different kind of low-angle shot to inject the scene with still more pathos.

Symbolic Perspective

Amid the chaos of the film's third act, Wes also employs low-angle shots to convey moments of introspection and melancholy. When Rat ambushes Mr. Fox's crew in the sewer, our hero finally gets the better of his adversary after a brief but electrifying scuffle. With Rat laying stricken on the ground, the camera cuts to Mr. Fox as he looks down before gently scooping up Rat's body. It's a poignant moment in which Mr. Fox, with Ash resting a supportive hand on his shoulder, is forced to confront his own mortality.

How to use low-angle shots 85

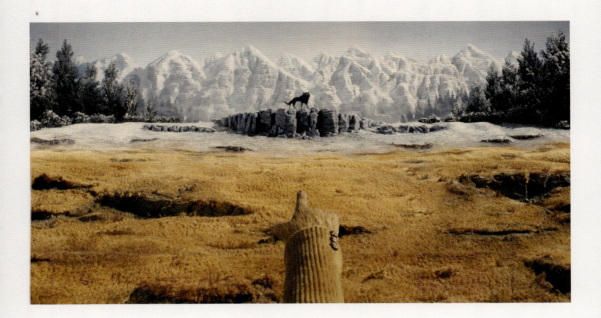

Above: Mr. Fox points out the mysterious Wolf in a classic Wes low-angle shot, which is also a good example of first-person perspective.

Character Development

In addition to serving as a tool for character development, low-angle shots in *Fantastic Mr. Fox* play a crucial role in exploring certain thematic elements of the story. Chief among the themes of the film is the tension between conformity and individuality, as exemplified by Mr. Fox's struggle to reconcile his wild instincts with the responsibilities of family life.

One of the most memorable moments in the film comes when Mr. Fox, his nephew Kristofferson (Eric Chase Anderson), Kylie (Wallace Wolodarsky) and Ash chance upon the mysterious black Wolf, who is perched atop a dark rock set against a wintry mountain landscape. Despite expressing his phobia of wolves on more than one occasion, Mr. Fox greets his natural enemy with admiration and respect.

Having spent much of the film grappling with his desire to live a more natural life, free from the constraints of society, Mr. Fox finally comes to the realization he will need to summon all of his primal urges in order to vanquish the farmers and protect his family.

PHOTO EXERCISE

HERO SHOTS

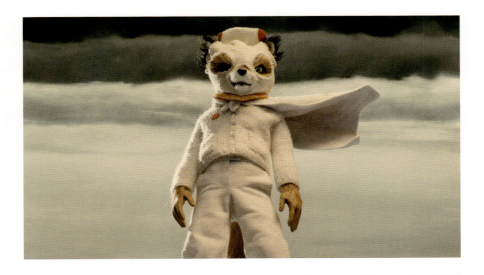

Creating a 'hero shot' portrait involves capturing your subject from a low angle to emphasize their presence and create a confident, commanding image.

88　Fantastic Mr. Fox (2009)

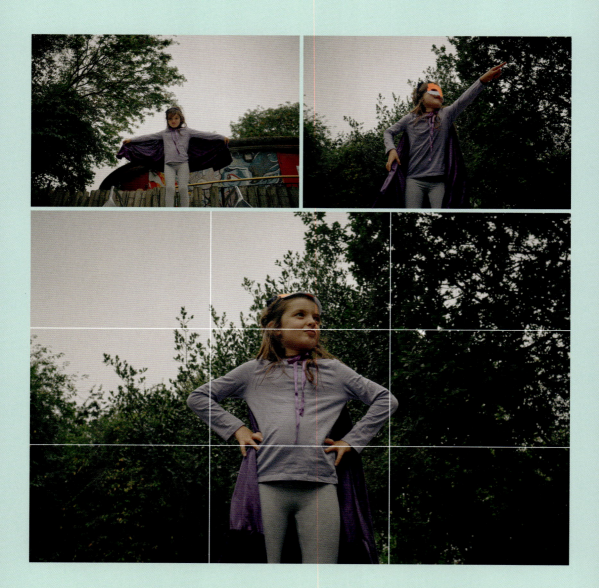

How to use low-angle shots

1 CHOOSE A CHARACTERFUL COSTUME
Style your subject in clothing that reflects a specific character trait. Wes's characters always have distinct personal styles that convey not only their personality but also their role within the story. As with the reference image from *Fantastic Mr. Fox*, we've taken the theme of this exercise quite literally, but you don't have to dress your subject in a cape and mask to create a compelling hero shot.

2 GET LOW
Position yourself at a low angle relative to your subject, with the camera tilted up approximately 45 degrees. This will make your subject appear larger, more dominant and more heroic. Have them stand tall and straight, ideally on a slightly elevated surface like a mound, steps or a small platform to further accentuate the effect. Frame the shot so that your subject occupies a significant portion of the frame. Carefully consider who you shoot from this angle, as it won't necessarily flatter everyone.

3 USE THE SKY
Because this shot is all about accentuating the heroism of your subject, the sky makes for an ideal backdrop against which to frame them. Consider first of all what challenge your hero is facing. For example, if they're in a dangerous situation, then a dark, moody sky will lend gravitas to your scene. Or, if your hero is about to make a grand romantic gesture, perhaps shooting at sunset could be most appropriate.

4 CENTRE YOUR SUBJECT
Again, positioning your subject in the centre of the frame will create a balanced composition, while at the same time enhancing the heroic effect you are trying to achieve. The rule of thirds also applies here, so think about where your subject's eyeline sits in the frame; it should be level with the top third line. Ideally, there should be no foreground visible, but if there is, ensure that any leading lines draw the viewer's eye to your subject.

5 STRIKE A POSE
Encourage your subject to strike a strong, assertive pose: hands on hips, arms crossed or any other kind of powerful stance will give them a more heroic air. A serious expression often works best for hero shots, though a subtle smile can also convey confidence and strength. Ask your subject to think about something they are passionate about or to recall a moment when they felt especially proud or empowered.

Top left: The background here is too busy, resulting in the subject standing out less against it and their expression being lost.

Top right: Here, we tried to play around with the subject's pose, but felt we strayed a little too far away from the reference image.

Bottom: You may find it useful to follow the rule of thirds when checking composition. Here, the subject's eyeline sits on the top third, while their elbows are roughly in line with the horizontal third lines, making the image more symmetrically appealing.

MOONRISE KINGDOM (2012):

HOW TO SHOOT CLOSE-UPS

Moonrise Kingdom (2012)

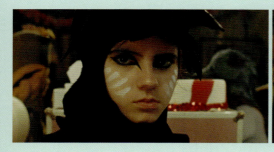

How to shoot close-ups 93

A coming-of-age romance about young lovers on the lam, *Moonrise Kingdom* (2012) is a film filled with intimate moments designed to highlight the innocence and vulnerability of its pre-teen protagonists. The way Wes uses close-ups in the film serves not only to underline Sam (Jared Gilman) and Suzy's (Kara Hayward) devotion to one another, but also to deepen our emotional connection to the characters as they journey across the fictional island of New Penzance.

Mutual Attraction

The first instance of this arrives early in the film when Sam and Suzy meet at their agreed rendezvous point to carry out their plan to run away together. In a sequence of shot-reverse shots, Wes frames each actor in close-up, carefully matching their eyelines and facial expressions, and establishing a visual motif that recurs throughout the film. The way that Sam and Suzy look at each other instantly conveys their mutual attraction and curiosity with one another.

Cinematographer Robert Yeoman shot *Moonrise Kingdom* entirely on Super 16mm film, a stock which generates wider images than larger formats like 35mm. It also offers a greater dynamic range and has a distinctive grain that evokes a sense of nostalgia, making it perfect for a film set in the mid-1960s. This, combined with the type of close-ups previously described, makes the film's depiction of early adolescence – with all the tentative feelings and intense urges that come with it – all the more authentic.

Mirrored Meet-Cute

Straight after Sam and Suzy's reunion in the meadow, the film flashes back to their first encounter one year earlier at a summer pageant. Backstage after a performance of Benjamin Britten's *Noye's Fludde* at a local church, Sam spies Suzy through a gap in a clothes rail, stepping through to introduce himself by way of enquiring about her costume. Instead of Wes overselling the idea of love at first sight, the scene gradually builds to a pair of close-ups that mirror those in the previous scene before Sam and Suzy's meet-cute is interrupted and Sam disappears back through the clothes rail.

Close-ups are used to raise the dramatic tension and emotional stakes at pivotal moments in the narrative, such as when Sam and Suzy are confronted by a gang of Khaki Scouts in the woods. The leader, Redford (Lucas Hedges), initially taunts the pair, like any self-respecting movie villain would in this situation. During this tense exchange, Wes cuts away to two other members of the troop in close-up: one wearing a neckerchief around his face and clutching an axe; the other smirking with an archer's bow slung over his shoulder. The irony, of course, is that the ensuing clash ends almost as quickly as it begins – and it doesn't end well for the scouts.

Not long after repelling Redford and the other scouts, Sam and Suzy take refuge in a secluded cove. After setting up camp, they scramble up a rock overlooking the cove and the camera closes in on their faces, which are romantically lit by the soft glow of the setting sun. Only this time,

Top: In *Moonrise Kingdom* (2012), close-up shots typically come in pairs, like when Sam (Jared Gilman) and Suzy (Kara Hayward) size each other up across a field.

Middle: This close-up of Sam, viewed from Suzy's perspective, mirrors the previous shot and perfectly captures his expression.

Bottom: As the scene unfolds, Wes uses another pair of close-ups during a flashback to Sam and Suzy's first meeting, instantly establishing their connection.

Moonrise Kingdom (2012)

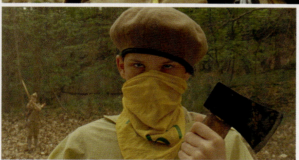

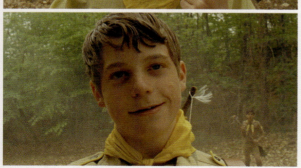

Wes frames the couple in an over-the-shoulder close-up, repeatedly cutting back and forth between them as they learn more about each other.

It's the first time in the film that we see either character open up on a deeper level, sharing their hopes for the future, their fears and desires. In this tender moment, Wes underscores the theme of existential yearning that permeates the film – the desire to break free from the confines of society and explore the unknown.

How to shoot close-ups

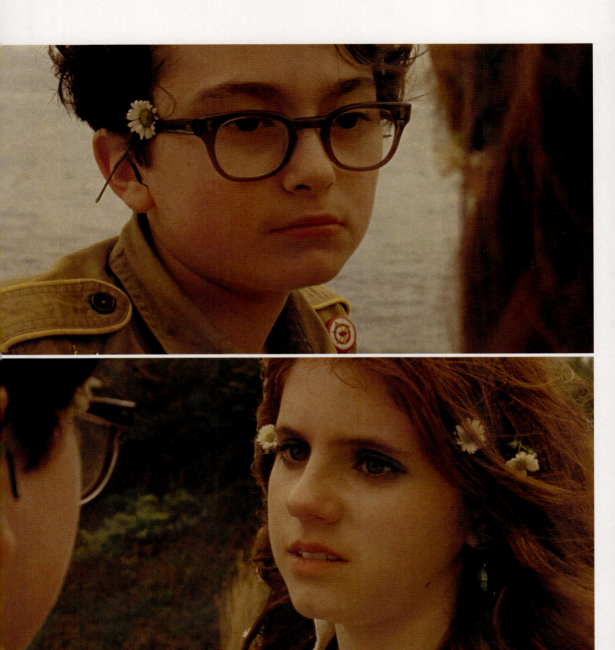

Opposite: When Sam and Suzy are ambushed in the woods, a string of close-ups leaves us in no doubt as to the Khaki Scouts' intentions.

Above: In one of the film's most romantic scenes, Wes shoots the close-ups within a classical over-the-shoulder set-up.

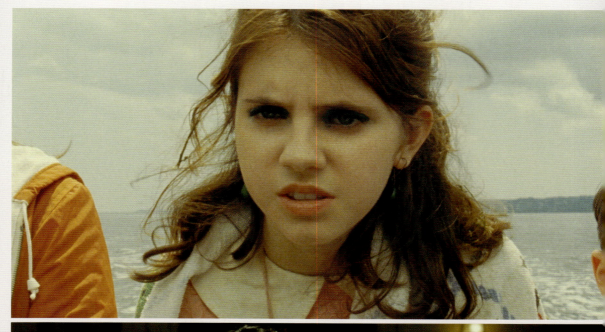

Opposite: Close-ups are an essential part of any filmmaker's toolkit, telling us exactly what a character is feeling, as in these examples of Suzy.

Above: During the film's stormy climax, Wes uses another pair of close-ups to heighten the emotional stakes of Sam and Suzy's last stand.

Expression and Gesture

It's in moments of intimacy such as this that Wes reveals the raw emotions that lie beneath the surface of his characters. Whether it's the quiet determination in Sam's eyes as he searches for his place in the world, or the pained look on Suzy's face as she confronts her troubled family dynamic, Wes's use of close-ups in *Moonrise Kingdom* encompasses the full spectrum of the human experience – even if only from the perspective of two lovestruck 12-year-olds. By isolating his characters within the frame, Wes is able to draw our attention to subtle nuances of expression and gesture, enriching our understanding of their inner lives.

Wes saves the best pair of close-ups in the film until last. With the island besieged by a storm of biblical proportions, everyone takes shelter in the church and Sam and Suzy attempt to disguise themselves in the *Noye's Fludde* animal costumes. But they're spotted by Captain Sharp (Bruce Willis) and so, fearing that Sam will be turned over to Social Services (Tilda Swinton), they attempt to escape via the steeple. As they contemplate taking a leap into the unknown, we are given a final glimpse of Sam and Suzy in close-up, demonstrating once and for all their undying commitment to each other.

PHOTO EXERCISE

FRAMING FACES

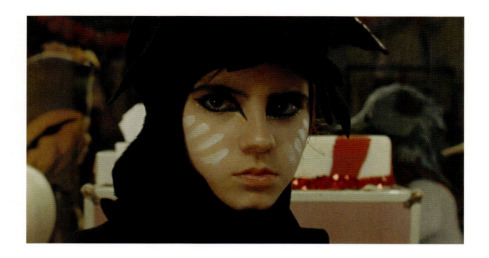

The aim of this exercise is to shoot a balanced and aesthetically pleasing portrait of a person in close-up, capturing their mood and personality.

100 Moonrise Kingdom (2012)

1 CHOOSE YOUR SUBJECT WISELY

This shot is all about the face. When choosing your subject, either go for someone with a particularly striking face, or – like Suzy in *Moonrise Kingdom* – get creative. This could mean playing with different makeup looks, facial props such as glasses or jewellery, or any other way you can think of accessorising a face.

2 DON'T OVERTHINK THE SETTING

Because this is such a tight shot, the setting is less important here than in some of the other exercises. However, you should still bear in mind that the background of the image tells a little of the story of your subject. If you want to replicate Wes's style, then choose your background accordingly to mimic a particular film of his. In this case, we opted to shoot in nature in order to evoke *Moonrise Kingdom*.

3 THINK LIKE A FILMMAKER

Consider the personal narrative or story you want the portrait to tell. Once you have established this and briefed your subject accordingly, provide direction to evoke specific emotions or moods. Authenticity is key, so always encourage your subject to express genuine emotions and gestures that would be true to their character.

4 CENTRE YOUR SUBJECT

Position your subject in the middle of the frame to create a balanced composition. You don't have to go for perfect symmetry, as Wes's close-ups are quite varied in this sense, but try to ensure that your subject's face takes up the majority of the frame. Their eyeline should sit on the top third line of the frame. Have them gaze into the lens to create a sense of intimacy and connection with the viewer.

5 EMPLOY NATURAL LIGHT

Soft daylight is your best friend when it comes to shooting portraits. Avoid harsh shadows and highlights that might obscure your subject's facial features or expression, aiming instead for even lighting that will flatter them and give you a more naturalistic shot. Overcast days or shaded areas can provide diffused light, which is ideal for close-ups.

Top: The angle is too low here, so it feels like the subject is looking down at us rather than looking us in the eye as if in conversation with us.

Bottom: Applying a grid overlay in-camera will help you to compose your shot according to the rule of thirds. In this instance, the subject's eyeline sits on the upper third line, which makes the image more engaging.

THE GRAND BUDAPEST HOTEL (2014):

HOW TO CREATE SYMMETRY

The Grand Budapest Hotel (2014)

How to create symmetry

Of all Wes's stylistic calling cards, symmetry is arguably the best known and the least understood. In each of his films, Wes's meticulous approach to composition creates an overall sense of balance and order that acts as a counterpoint to the unpredictability of the narrative. Nowhere is this more evident than in *The Grand Budapest Hotel* (2014), where Wes's penchant for symmetry is on full display from the outset.

Symmetry Meets Asymmetry

In the establishing scene, Wes uses the brick wall to separate the foreground from the background of the shot. The viewer's eye is immediately drawn to the doorway in the middle of the wall, which is further framed by the large, evenly spaced lettering painted on either side. This doorway not only acts as a portal to the rest of the scene but also to the wider story which we are about to be told.

At this point, it is worth noting that while the main subject of Wes's symmetrical compositions is almost always centred, the rest of the frame is typically filled with asymmetrical elements, such as the wheelbarrow and the VW campervan in the example opposite. A perfectly symmetrical image can seem uncanny or unrealistic, and can sometimes elicit a feeling of unease, so it's best to avoid a composition that mirrors itself exactly.

Dollhouse Aesthetic

From the opening moments of *The Grand Budapest Hotel*, Wes combines colours, costumes, props and other set elements to create a dollhouse-like environment. Wes is not alone in constructing perfectly self-contained cinematic worlds in this way, but his precision is such that his particular style has become instantly recognizable. Consider the following examples from *The Grand Budapest Hotel* – both shots are markedly different in terms of how they are lit and styled, yet they are similarly indicative of the dollhouse aesthetic that Wes is constantly striving for.

The first time we enter the titular hotel during its heyday (via a flashback), we're greeted by the sight of M. Gustave (Ralph Fiennes) standing with his back to the camera looking out over a balcony in one of the rooms, his silhouette symmetrically framed by a pair of lace curtains and the balcony doors. A few scenes later, Wes shows us the reverse angle, this time with M. Gustave standing outside the hotel next to lobby boy Zero (Tony Revolori). Just as symmetry can be used to demonstrate a character's loneliness, as in the first shot, it can also be used to establish a connection between two or more characters, as in the second shot.

Top: There's symmetry everywhere you look in *The Grand Budapest Hotel* (2014), right from the opening scene of an unnamed girl entering a graveyard.

Bottom: Wes typically uses symmetrical compositions to establish his signature dollhouse aesthetic, with the interiors of the titular hotel containing many such examples.

The Grand Budapest Hotel (2014)

Above: Symmetry can also be used to create contrast or separation between characters, like when M. Gustave (Ralph Fiennes) attends Madame D.'s (Tilda Swinton) will reading.

Opposite, top: M. Gustave cuts a lonely figure on a hotel balcony in another meticulously composed symmetrical shot.

Opposite, bottom: Wes often places objects within the frame to enhance the symmetrical effect, like these luggage trollies positioned behind M. Gustave and Zero (Tony Revolori).

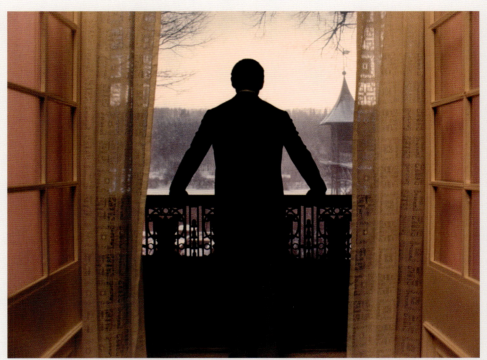
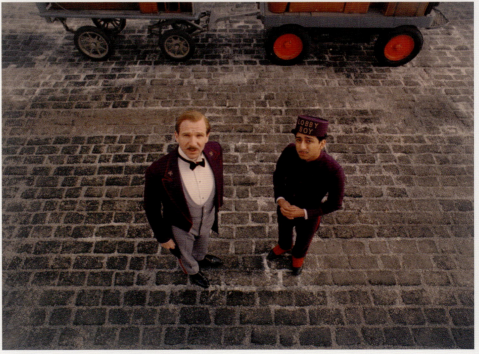

Top: Wes combines symmetry with one-point perspective in the scene where Agatha (Saoirse Ronan), carrying *Boy with Apple*, is tailed through a hotel...

Bottom: ...before switching to the perspective of her stalker, Dmitri (Adrien Brody), who is desperate to get his hands on the painting.

Dynamic Symmetry

The symmetry present in Wes's framing is not limited to static shots. The director also employs dynamic symmetry in a variety of intricate tracking shots that follow characters as they move through the hotel. For instance, the camera glides in step with M. Gustave as he sets about his day, revealing neatly aligned furniture, paintings and an evocative colour scheme that seems to be lifted straight from a dream. This methodical arrangement of visual elements creates a sense of harmony and structure that M. Gustave himself embodies, complementing the film's broader thematic exploration of order versus chaos.

The chase sequences in *The Grand Budapest Hotel* are another prime example of dynamic symmetry. As characters traverse the labyrinthine corridors and staircases of the hotel, often in hot pursuit of one another, the camera moves effortlessly along with them, conveying a sense of calm amid frantic action or nervous tension, like when Dmitri (Adrien Brody) stalks Agatha (Saoirse Ronan) with menacing intent in a bid to retrieve the stolen painting 'Boy with Apple'.

How to create symmetry 109

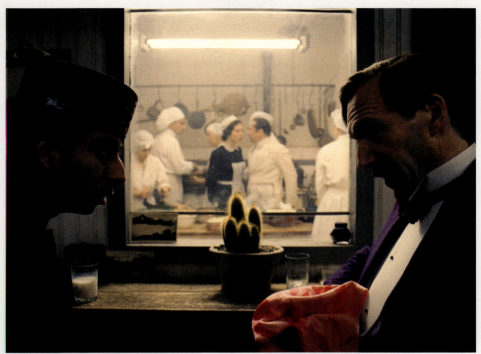

Top and Bottom: Wes often uses background elements to create balance. In these examples, a window and a door, respectively, help to frame Zero and M. Gustave symmetrically.

Narrative Symmetry

Wes's use of symmetry in *The Grand Budapest Hotel* extends to the film's structure. It is presented as a story within a story within a story, with each layer contributing to an overall sense of narrative symmetry. This nested storytelling approach mirrors the physical symmetry of the sets and reinforces the film's underlying themes of maintaining self-composure and upholding one's values in the face of destructive and malevolent forces.

Wes is also partial to repeating specific shots, sometimes across multiple films. In *The Grand Budapest Hotel*, there is a side-on two shot that occurs three times in a nearly identical manner, with M. Gustave always seated to the right of Zero, and always with a small glass of alcohol to hand.

Top: *The Grand Budapest Hotel* contains a lesser-known Wes trademark: a symmetrical shot where the camera is fixed on top of a moving train.

Bottom: An almost identical shot from *The Darjeeling Limited*.

Parallel Lines Converge

There's another shot in *The Grand Budapest Hotel* where the camera looks straight along the top of a moving train, which is reminiscent of a nearly identical shot in *The Darjeeling Limited* (2007). Wes mimics the composition of this shot again in *Asteroid City* (2023), this time mounting the camera on a miniature model. These images are also examples of one-point perspective, a technique favoured by Wes and often used in conjunction with symmetrical composition, where parallel lines converge to a single vanishing point on the horizon.

How to create symmetry 111

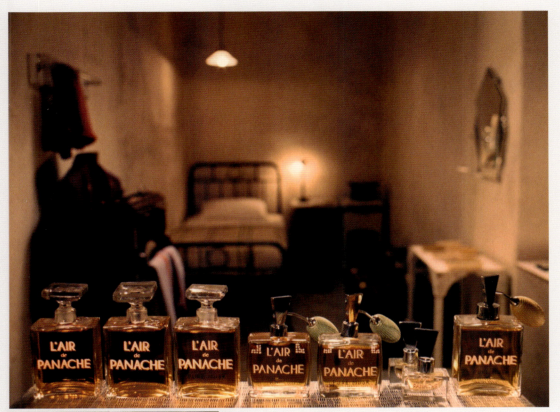

Top: In M. Gustave's quarters, Wes again adds props – the concierge's perfume of choice – to the foreground to create symmetry.

Bottom: The same technique can be found in Mendl's Patisserie; the shop's gruff owner arranging a trio of Courtesan au Chocolat on top of a counter.

All in the Details

Wes's obsession with symmetrical composition extends to the smallest elements. Whether it's the alignment of perfume bottles on a desk or artisanal pastries on a shelf, the visual components of each frame are arranged like the pieces on a chessboard, everything in its right place. By foregrounding such objects within a symmetrical composition, Wes imbues them with the utmost importance, simultaneously inviting us to pay close attention to them.

112 The Grand Budapest Hotel (2014)

PHOTO EXERCISE

SHOT-REVERSE SHOT

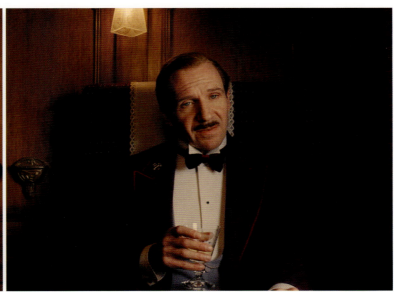

For this exercise, the objective is to shoot a pair of images showing two different subjects from contrasting perspectives, each aligned in the centre of the frame.

114　The Grand Budapest Hotel (2014)

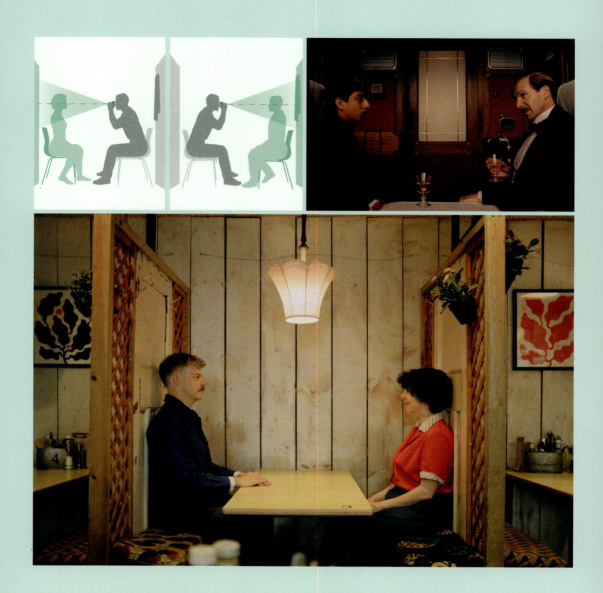

1 CHOOSE YOUR SETTING

Select a location that allows you to position your subjects facing each other. The amount of space you need between your subjects will depend on the width of the lens you are using. Settings that lend themselves well to this type of shot include restaurant booths, park benches and old-fashioned train carriages.

2 PROP THE BACKGROUND

While you want to create two images with matching compositions, it's a good idea to introduce some asymmetry. This can be simply achieved by ensuring there is an additional background element in one of the shots. Here, we hung an article of clothing on the wall next to one of the subjects. A small painting or light fixture would work equally well. Choose something that feels natural and not out of place within the context of the scene you are creating.

3 BALANCE THE LIGHTING

If you are shooting in an enclosed space, you will want to make sure that you have enough available light to make your image. Your chosen setting may have multiple light sources. If this is the case, ensure that the colour temperatures of the light sources are not too dissimilar. If your key light is artificial, make sure it doesn't cast heavy shadows on your subjects (especially their eyes).

4 TALK TO ME

In order to make this shot, you will have to sit opposite each subject, taking it in turns, so that you can achieve the look of them facing one another. From your eye height, take the image pointing your camera directly at the person opposite you. These images should feel exactly as though the subjects are in conversation with each other.

5 ADD IN YOUR VIEW

While these portraits work well as a pair, you can add a third perspective: your own. To do this, have both of your subjects take their seats and then step back to capture the whole scene side-on. Make sure they remain facing each other as though engaged in conversation, and that your camera is completely flat to the scene. This will add some cinematic distancing and give the viewer a different vantage point.

Top left: Sit directly across from your subject, and then swap with them in order to shoot your next subject from the opposite perspective.

Top right: M. Gustave and Zero viewed side-on in a train carriage, positioned either side of the carriage door to create a balanced composition.

Bottom: This is an example of how to create symmetry from a different perspective; Wes will often use this technique to complement a shot-reverse shot in a scene.

ISLE OF DOGS (2018):

HOW TO USE FIRST-PERSON POV

Isle of Dogs (2018)

In the stop-motion animated caper *Isle of Dogs* (2018), Wes makes great use of one of his favourite techniques to fully immerse the audience in the story – not just from the perspective of the human characters, but the canine ones, too. Set in a dystopian near-future Japan in the fictional city of Megasaki, the action primarily takes place on Trash Island, a sprawling refuse site where all of Megasaki's dogs have been banished following a severe outbreak of snout fever. Most of the film is seen from the point of view of the dogs, whose barks are 'translated' into English in order to place English-speaking viewers firmly on their side. (It's worth noting that when the human characters speak, they do so in their native Japanese; occasionally they are translated by English-speaking interpreters.)

Wes uses first-person POV (point of view) early on in *Isle of Dogs* when two rival packs fight over a highly prized pile of rotting food. More often than not, Wes prefers to shoot first-person POV from a top-down perspective, with the subject of the image framed as though it is being viewed through the character's eyes. This approach enables him to communicate a great amount of information in a single image, and in *Isle of Dogs* it is also used as a way to show off the incredible handcrafted props that were designed for the film, be it a bag of waste or a bitten-off ear.

Empathetic Perspective

Perhaps the most important narrative dimension of the film is the relationship between top dog Chief (voiced by Bryan Cranston) and 12-year-old Atari Kobayashi (Koyu Rankin), who ventures to Trash Island in search of his beloved pet, Spots (Liev Schreiber). Through a succession of intimately framed first-person POV shots, we get to experience the growing bond between Atari and Chief from their distinct perspectives, and begin to empathize with their respective plights.

When Atari crash-lands on the island, Wes uses first-person POV to establish a connection between him and Chief's crew, showing a semiconscious Atari from one of the dogs' points of view before switching to the reverse angle. This is followed by a pair of shots which draw a direct parallel between Atari's emotional journey and the plight of the exiled hounds. Through this scene, Wes sets the tone for the film's exploration of resilience and human-canine companionship.

One of the most common types of first-person POV shot that appears throughout Wes's filmography is when a character studies a piece of printed material, thereby inviting the audience to do the same. This could be a book, a letter, a map, or in the case of *Isle of Dogs*, a top-secret dossier containing the blueprints for a military-grade robot attack dog. Whenever this kind of shot occurs in one of Wes's films, it is worth paying extra-close attention, because invariably the image is loaded with expositional significance, whether its function is to foreshadow an event or to flashback to an earlier one.

Top: A festering pile of garbage looks like a veritable banquet from the perspective of one of the canine protagonists in *Isle of Dogs* (2018).

Middle: By contrast, a severed ear seen from the same POV creates a strikingly melancholy image.

Bottom: By employing first-person perspective, the audience sees exactly what the character sees; in this case, a secret folder loaded with expositional detail.

Top: Another example of a first-person POV shot occurs when Atari (Koyu Rankin) crash-lands on Trash Island.

Bottom: In a reverse shot, we see Rex (Edward Norton) from Atari's perspective.

How to use first-person POV 121

Top: As a dazed Atari sits up, Wes uses a wider-angle first-person POV to place us inside Atari's helmet.

Bottom: By matching the position of top dog Chief (Bryan Cranston) with the photograph of Atari's lost pet, Wes creates an instant connection between them.

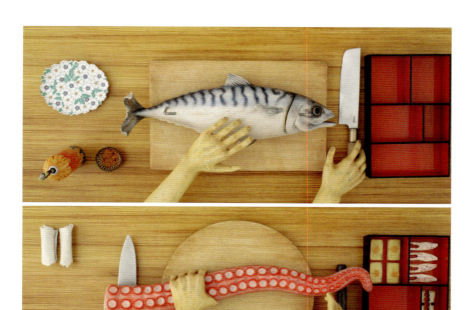

Top and Middle: In one of the most impressive scenes in the film, Wes stages an elaborate sushi-making scene, as viewed from the chef's perspective.

Bottom: The delivery label on the bag of sushi contains a crucial piece of information that spells bad news for its intended recipient.

Perfect Preparation

Wes also uses first-person POV in *Isle of Dogs* to pay tribute to Japan's rich culture and traditions. One of the most notable examples of this is a wordless scene depicting a master sushi chef methodically preparing a bento box consisting of various sea creatures, an astonishingly detailed 45-second sequence which took a team of animators seven months to create, including a painstaking month-long filming process.

Upon first glance, this visually satisfying scene might appear to exist solely to provide Wes with an excuse to flex his stop-motion muscles. But then our attention is drawn to the chef adding a pinch of wasabi to the nigiri before carefully bagging up the meal and filling in the delivery address label. Knowing that the intended recipient is Professor Watanabe (Akira Ito), whose bid to develop a cure for snout fever is initially thwarted by the vindictive Mayor Kobayashi (Kunichi Nomura), the sushi-making scene suddenly takes on a more ominous meaning.

How to use first-person POV 123

Top: The photograph of Spots (Liev Schreiber) being held tenderly by Atari is a recurring image in the film.

Bottom: First-person perspective has the power to imbue something as banal as a dog biscuit with great emotional weight.

Mirrored Motifs

As the story progresses, we witness Chief's gradual transformation from reluctant companion to loyal protector of Atari. When the pair are separated from the rest of the pack, finding themselves in the abandoned Kobayashi Park fairground, a moment of compassion prompts Atari to give Chief – a proud stray – a much-needed bath. When Chief emerges freshly groomed, he looks remarkably like Spots, and Atari hands him a treat he had been saving for his missing pooch, evoking a poignant first-person POV shot from earlier in the film.

Wes returns to the image of a bento box at the end of the film, this time flipping the tables on Mayor Kobayashi. After Kobayashi's executive decree to banish all dogs from Megasaki is overturned, he is convicted for political corruption along with his accomplices. In prison, we see a tray of food framed from Kobayashi's perspective that looks much less appetizing than the sushi made for Professor Watanabe. Visual callbacks like this are littered throughout Wes's films, and they are often used to underscore a cathartic or climactic moment.

PHOTO EXERCISE

FIRST-PERSON PERSPECTIVE

The idea here is to shoot an object in the centre of the frame while creating the effect of it being viewed from the perspective of an unseen protagonist.

Isle of Dogs (2018)

How to use first-person POV 127

1 CHOOSE YOUR FOCAL POINT
Decide on the subject of your photograph. Think about what you want to convey with your image and how best to frame the focal point from a first-person point of view. To illustrate this exercise, we chose a small photograph, similar to the one found in *Isle of Dogs*. Remember that, as outlined in the next chapter, the objects and props that Wes chooses always tell a story.

2 CHOOSE YOUR SETTING
It is a good idea to shoot against a relatively flat surface that will give you an even contrast and tone, as you don't want your focal point to get lost against the background. Choosing a setting with a bit of colour and texture can help to bring a sense of character and place to the scene. We chose a backdrop with a predominantly grey and brown palette to match the glove and the photograph.

3 GET IN POSITION
Position yourself in a way that accurately represents a first-person point of view. Consider the angle, height and orientation of the camera to mimic the sightline of your protagonist (i.e. the person holding the photograph). If you have someone assisting you to hold the focal point, you will likely need to be looking directly over their shoulder. So, if they are holding the photograph in their right hand, you should position yourself to their left, and vice versa. This will enable you to line up the shot correctly.

4 FIND THE BEST ANGLE
Once you've figured out your own position, adjust the position of your camera until your focal point is centred within the frame. If your chosen background features straight lines, make sure they align neatly with your object for balance. Consider what your subject is holding and choose an angle which tells the story. The photograph held in our image sits in front of a mural of dogs, suggesting the protagonist is searching for their own dog among the furry faces.

5 STAY FOCUSED
Whether using a camera or camera phone, you should be able to control either the aperture or the blur effect in your image. Play around with the depth of field here, particularly if, like us, you are using a background which ties into your narrative. If the focus is too shallow, the detail will smudge out of focus behind your pin-sharp object in the foreground. If it's too deep, the background could be too detailed, stealing the limelight from your object. Experiment and find the sweet spot.

Top left: Position yourself as close to your subject as possible, placing your camera over their shoulder to capture the focal object.

Middle: In this outtake, the darker glove and wider background both detract from the focal point (the photo being held).

Bottom: These two images show opposing examples of depth of field: the left is shot at f/2.8 and is too shallow; the right is shot at f/11 so the focus is too sharp across the whole image.

THE FRENCH DISPATCH (2021):

HOW TO USE PROPS

The French Dispatch (2021)

How to use props

Props are an essential part of any film. They can help to establish the setting and time period of a story and provide tangible elements for the actors to interact with, giving the audience valuable insight into the characters' personalities, interests and backgrounds. Just as the items a character surrounds themselves with can reveal a lot about who they are and what they value, a well-chosen prop can also enhance the aesthetic quality of a scene – and few directors working today understand this better than Wes.

World-Building Tool

In *The French Dispatch* (2021), Wes demonstrates how props can be a powerful world-building tool, from hand-made graphic elements that appear in the background to physical objects that are given a character arc all of their own. Set in the fictional French town of Ennui-sur-Blasé, this anthology film unfolds as a collection of stories published by the eponymous magazine, each offering a glimpse into the lives of the town's colourful inhabitants. Wes uses props to enrich the viewing experience and convey narrative meaning at various points throughout the film, crafting a world that feels at once authentic and lived-in.

An early example of this occurs during the prelude to the first segment. In a *bar tabac* next door to the magazine's headquarters, a waiter nimbly arranges cups of coffee, numerous alcoholic beverages, a pack of cigarettes and a box of matches on a rotating silver tray before making his way along the M.C. Escher-esque network of staircases and corridors leading to the office of *The French Dispatch*'s editor-in-chief, Arthur Howitzer Jr. (Bill Murray).

Precise Arrangement

Most directors would not bother to pay such close attention to the precise arrangement of a drinks tray, but in doing so, Wes makes it clear that this elaborate dance is part of a daily ritual. More to the point, each item on the tray, much like the assortment of stationery on Howitzer Jr.'s desk, adds to the picture that Wes is painting.

Speaking of which, the first of the film's three main stories, titled 'The Concrete Masterpiece', is introduced through a static shot of a paint-splattered trolley filled with art supplies, standing against a blank wall. Wes repeats this motif at the start of the second and third segments, showing a burnt-out Citroën 2CV on a brick-strewn cobbled street, and a rustic kitchen where several meals have been prepared, respectively.

Collectively, the props in these images provide context for each segment while simultaneously contributing to the overarching tone that Wes is aiming to convey. In the case of 'The Concrete Masterpiece', the art trolley hints at the impulsive creative process – not to mention the muddled psyche – of incarcerated virtuoso Moses Rosenthaler (Benicio del Toro).

Top: Wes never uses props lightly: in *The French Dispatch* (2021), a simple drinks tray tells us everything we need to know about the eponymous magazine staffers.

Bottom: Each of the main stories within the film opens with a painterly title card containing props pertinent to the narrative.

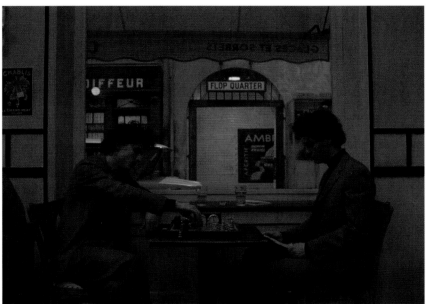

Top: Student revolutionary Zeffirelli (Timothée Chalamet) plays chess with a peer at local hangout Le Sans Blague.

Bottom: More period-accurate props are visible in the café when Mitch-Mitch (Mohamed Belhadjine) returns from national service.

Period Accuracy

Meanwhile, in 'Revisions to a Manifesto', which tells the story of a group of teenage revolutionaries led by chess-loving, ill-fated firebrand Zeffirelli (Timothée Chalamet), Wes decorates the neighbourhood hangout spot, Le Sans Blague café, with an array of period-accurate advertising posters created for the film by graphic designer Annie Atkins. These are not intended to take our focus away from the characters; they exist in the scene simply to make the set appear more realistic and true to the world of the film.

Wes also utilizes props to underscore the themes of nostalgia and memory that permeate *The French Dispatch*. Later in the same segment, Zeffirelli attempts to broadcast his revised manifesto from a radio tower before the antenna malfunctions. As Zeffirelli scrambles to fix the issue, Wes cuts to a series of similarly composed shots of various Ennui-sur-Blasé residents who have tuned in to hear Zeffirelli speak and are now urgently adjusting their transistor radios. Like us, they are all eager to find out what happens next.

How to use props 133

Above: A shrine to Zeffirelli, seen in both close-up and wider shot with his allies nearby, shows some of the props created for the film, including his fêted manifesto and an LP by the fictional pop star Tip-Top.

Familiar Objects

After tragedy strikes at the top of the radio tower, the segment is brought to a terse close by journalist Lucinda Krementz (Frances McDormand). As she contemplates Zeffirelli's legacy ('*His likeness, mass-produced and shrink-wrap packaged, will be sold like bubblegum to the hero-inspired who hope to see themselves like this*'), we see a variety of familiar objects neatly arranged to form a shrine in front of the now-shuttered Le Sans Blague – a collection of props that encapsulate the short life of an idealistic if narcissistic young martyr.

During the brief narrative segue into the final segment, we see Krementz sitting at a typewriter eating toast as Howitzer Jr. enters to read her report on Ennui-sur-Blasé's youth movement. The room is decorated with nothing more than a few stacks of books and journals, reinforcing the image of a lonely woman who is committed to her work and little else.

The last time we see Krementz in the film she is sitting in Howitzer Jr.'s office next to a bookcase, contemplatively smoking a cigarette while wearing the same red coat, perhaps indicating that she is destined to go the same way as her recently departed boss; to die doing what she loves. Subtle visual links such as this appear throughout Wes's filmography, each carefully placed prop adding a layer of depth to his cinematic worlds.

134 The French Dispatch (2021)

Above: Shortly before Zeffirelli meets his untimely demise, Wes's love of vintage technology – specifically transistor radios – is on full view.

How to use props 135

Top: Lucinda Krementz (Frances McDormand) sits at her typewriter as her editor, Arthur Howitzer Jr. (Bill Murray), appraises the first draft of her article.

Bottom: Stacks of books are associated with both Krementz and Howitzer Jr., as this shot in the latter's office shows.

The French Dispatch (2021)

PHOTO EXERCISE

ANDERSONIAN ARRANGEMENTS

The aim of this exercise is to shoot a still-life image, incorporating an assortment of carefully arranged props that together tell a story.

1 CRAFT A NARRATIVE

This set-up relies entirely on the props you are shooting, therefore it is useful to decide on a narrative before you set up your scene. In this case, we created a shrine to a (fictional) recently departed blues fan, imagining how his love for his favourite music would have shaped his personality. Think about the themes and motifs commonly found in Wes's films, such as family, nostalgia and memory.

2 SOURCE YOUR PROPS

Gather a collection of objects that feel evocative of Wes's aesthetic. Kris Moran, who has worked as a set decorator on several of Wes's films, including *Moonrise Kingdom* and *Asteroid City*, has said that many of the props sourced by her team came from auction houses, thrift stores and online marketplaces like eBay. Look for items with strong colours or ones that give off a certain vintage charm.

3 ARRANGE YOUR ITEMS

Create a carefully curated scene for your props. Start by placing the larger items in the centre and then build the scene around them. Consider using a symmetrical composition with props arranged in a balanced and visually pleasing manner. Make sure the background complements the style of your props, whether it's a doorway, an outside wall or somewhere else. Keep a colour theme in mind, and try to find a background whose main colour provides a contrast.

4 SET UP YOUR CAMERA

Once you have created your scene, position your camera as though you are standing dead in front of it, looking down. To recreate the reference image, you will need to place your camera a metre or so from the props, at roughly shoulder height, and point the lens down about 45 degrees. Using a tripod will not only help to stabilize your image, but will also allow you to move items around without altering the position of the camera.

5 CHECK YOUR COMPOSITION

Ensure you have created a balanced composition with props evenly distributed to give the scene a sense of order and harmony. The image doesn't have to be exactly symmetrical, so long as the overall composition feels cohesive and intentional. You can always crop the image after you have taken the shot, but it's best to get it right in-camera. Check that everything is in focus; you don't want to miss any details.

Top: Although the composition is close to the reference image, the multicoloured background is too dominant, meaning the props don't stand out enough.

Bottom: This image has the same issue as the one above, but also shows how placing too many props on one side can create an unbalanced scene.

ASTEROID CITY (2023):

HOW TO SHOOT BUILDINGS

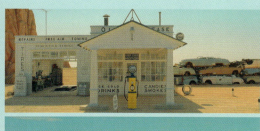
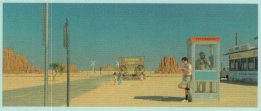
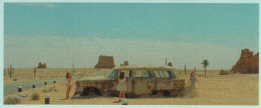

How to shoot buildings

As discussed in Chapter 4, Wes and cinematographer Robert Yeoman typically use 35mm analogue film cameras fitted with anamorphic lenses to create panoramic compositions with a deep depth of field so that everything is in focus. The pair put this approach to great effect in *Asteroid City* (2023), bringing the titular desert town to life by shooting the exterior set – which was custom-built just outside the town of Chinchón, Spain, about an hour from Madrid – extremely wide and embracing full overhead sunlight to sell the idea that the location is actually the American West circa 1955.

Because *Asteroid City* is structured as a televised stage play that is simultaneously being rehearsed and performed within the film, Wes also utilizes a compositional technique known as planimetric staging, where the camera is placed perpendicular to the central figures and background elements of the image, making the entire frame appear like a flat canvas. One reason for using this technique is to constantly remind the audience that the town is, in fact, a set for a theatrical production.

Shooting Flat On

Nothing demonstrates this better than the way Wes frames the buildings which form *Asteroid City*, from an old-timey diner to a motel to a service station. These buildings are almost always shot flat on, giving them a two-dimensional quality. In a behind-the-scenes featurette, Wes explains that he and his regular production designer, Adam Stockhausen, set out to 'make buildings that were as evocative of the time' as they possibly could, and this choice of framing instantly conjures a retro postcard-like aesthetic.

As well as meticulously storyboarding his films, Wes often builds scaled-down model versions of his sets during preproduction so that he and his production team can see how everything will fit together. Of course, you don't have to go that far with your own photography; simply choosing the right lens and positioning yourself at the correct distance will allow you to take images of buildings that have an aesthetically pleasing composition.

Off-Centre Horizon Line

The same rules apply for shooting any exterior scene that has a specific object or structure as its focal point. The trick is making sure that the frame is balanced so that the subject(s) in the foreground and background of the image do not distract from one another. It is also a good idea to consider where the horizon line is.

In *Asteroid City*, Wes tends to position the camera so that the horizon is just below the centre of the image, which allows the foreground elements to stand out more. He also keeps the midground uncluttered so that the viewer's eye is drawn to the characters in the foreground and the thing they are interacting with, for example, a telephone box or a derelict car. Meanwhile, the natural negative space created by the sky helps to establish the relative scale of the large rock formations that make up the background scenery.

Top and Middle: Early on in *Asteroid City* (2023), Wes introduces us to the eponymous desert town via a sequence of establishing shots of buildings, from a humble diner to a motel forecourt.

Bottom: Three more shots of buildings or man-made structures, all of which contribute to the film's authentic period setting.

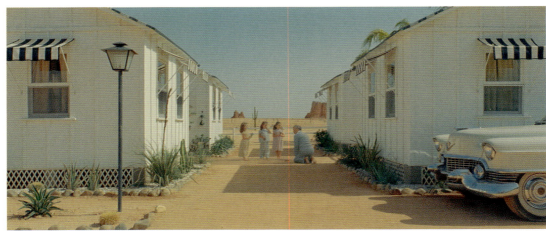

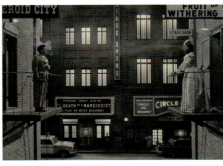

Top: Wes often uses buildings to frame characters within a scene, here making particular use of negative space when Stanley Zak (Tom Hanks) addresses his granddaughters…

Bottom: …and again when Augie Steenbeck (Jason Schwartzman) meets a fellow actor (Margot Robbie) backstage.

Negative Space

Negative space can also be used to create a more symmetrical composition. The cosy motel cottages in *Asteroid City* are arranged in a neat grid, and Wes frequently stages scenes in the narrow gaps separating them. Here, he incorporates limited foreground detail, while a strategically placed cactus also helps to provide an accurate sense of scale between the actors and the distant background landscape.

Wes uses a similar technique during the black-and-white section of the film, when actor Jones Hall (Jason Schwartzman), who is playing war photojournalist Augie Steenbeck in the production of 'Asteroid City', and an actress from a different play (Margot Robbie) have a brief conversation on a pair of facing backstage fire escapes. This time, the background is dominated by two adjoining Broadway-style theatres, with the planimetric composition flattening the scene to bring everything into sharp focus.

How to shoot buildings 145

Above: Shooting buildings anamorphically allows Wes to create frames within the frame, like when Dr. Hickenlooper (Tilda Swinton) shows Dinah (Grace Edwards) around the observatory.

Accentuating Shape

Occasionally, Wes uses anamorphic lenses to accentuate the shape of buildings. In the scene in *Asteroid City* where astronomer Dr. Hickenlooper (Tilda Swinton) shows a couple of inquisitive young space cadets around the local observatory, the curvature of the building, as well as the large round stones it is comprised of, is emphasized by the wide framing and slightly low-angle camera placement, while the subjects are positioned centrally in a frame within the frame.

Buildings play an important role in all of Wes's films, and he often frames them in such a way as to showcase their architectural features, even when the audience's immediate attention is elsewhere. This intentional framing underscores the significance of the built environment within the narrative, giving each setting a sense of character and history, while also contributing to the overall atmosphere of the film. Whether he is portraying a grand townhouse, a palatial hotel or an old-fashioned diner, Wes's use of wide anamorphic lenses allows him to highlight the physical form of buildings and accentuate their presence on screen.

PHOTO EXERCISE

WIDE-ANGLE EXTERIORS

For this final exercise, the goal is to create a symmetrical composition in which the facade of a building is the main focus.

How to shoot buildings 149

1 SELECT A STRUCTURE
Wes makes no secret of his love of period architecture with a retro or vintage feel, but really the building you choose can be from any period and in any style, so long as it has interesting colours and design features. From cottages to *grand palais*, anything goes (but try to avoid generic buildings or overused landmarks). Buildings with brightly coloured facades, characterful doorways or picturesque windows are a good place to start.

2 FIND YOUR ANGLE
Once you've chosen your building, find the best angle to shoot it from. If you've chosen a large building, you may benefit from using a wide-angle lens if you have one. Or, if you are shooting on a camera phone, select wide-angle mode in your camera's settings. Using a wide-angle lens will allow you to capture more of the scene without having to position yourself too far from the building.

3 CREATE NEGATIVE SPACE
Whether your building is situated in an urban or rural environment, among other buildings or standing on its own, you are going to need to position yourself far enough away to capture it in its entirety, while still keeping some of the sky above in shot, and without cluttering the foreground. You'll probably want to isolate the building within the frame, unless it happens to be part of an equally interesting row of buildings. You don't want too much negative space, just enough to isolate your building. Outside of a city, these conditions will be much easier to find, as buildings are more likely to stand alone.

4 STUDY THE SKY
Try to shoot when the weather conditions are consistent; a clear sky or blanket cloud is preferable. Be mindful of the direction and quality of light. If it's a sunny day, wait for the right time to shoot when the light is on the building. You don't want the building to be backlit because this means you will lose the details. Ideally, the background should be as tonally even as possible.

5 USE THE HORIZON
As with the photo exercise in Chapter 3, shooting against a backdrop where the horizon is visible will not only give your image a sense of scale, it will also help you achieve a balanced composition. Parallel lines are aesthetically pleasing, so make sure that any horizontal lines in your image, including those which feature on your building, are level.

Top left: Use the viewfinder to ensure your subject is framed centrally, then adjust the height of your camera so that the horizon line bisects the image.

Middle: Although this is quite a Wes-like scene, the lamppost and uneven pavement rather ruin the composition. It's best to avoid such visual distractions.

Bottom left: As above, the rubbish bin spoils the shot, but also the horizon line is not visible here, making the image less impactful.

Bottom right: Use the rule of thirds to make sure the horizon line sits in the centre of the frame, while the top of the building sits no higher than the top third, as in the reference image.

FURTHER RESOURCES

RECOMMENDATIONS

BOOKS

Bramesco, Charles, **Colours of Film: The Story of Cinema in 50 Palettes**, Frances Lincoln, 2023

Fulford, Jason (ed.), **The Photographer's Playbook: 307 Assignments and Ideas**, Aperture, 2014

Higgins, Jackie, **Why It Does Not Have To Be In Focus: Modern Photography Explained**, Thames and Hudson Ltd, 2013

Monks Kaufman, Sophie and Little White Lies, **Close-ups: Wes Anderson**, William Collins, 2018

Wada, Sanzo, **A Dictionary of Color Combinations**, Seigensha Art Publishing, 2011

Woodward, Adam, **The Worlds of Wes Anderson**, Frances Lincoln, 2024

Zoller Seitz, Matt, **The Wes Anderson Collection**, Abrams, 2013

PHOTOGRAPHY APPS

All the original images in this book were captured on a Fuji X100f camera.

VSCO:
Mobile photo editing app

Adobe Lightroom:
Image processing app that allows you to shoot RAW images on your phone

Adobe Photoshop:
Image editing software

RNI:
Film emulation filter packs

FILMOGRAPHY

FEATURE FILMS

Bottle Rocket (1996)
A trio of slackers go on a short-lived crime spree across Texas in a bid to become master thieves.

Rushmore (1998)
An eccentric teenager competes with a tycoon for a teacher's affection at a prestigious Houston prep school.

The Royal Tenenbaums (2001)
A highly dysfunctional upper-middle-class family are reunited in this comedy of manners set in New York City.

The Life Aquatic with Steve Zissou (2004)
An unethical oceanographer risks his life and reputation in order to avenge his best friend in this nautical caper.

The Darjeeling Limited (2007)
Three estranged brothers rekindle their sibling rivalry while embarking on a spiritual train journey across India.

Fantastic Mr. Fox (2009)
A proud and cunning fox finds himself in a high-stakes game of chicken with some particularly irritable farmers.

Moonrise Kingdom (2012)
Two precocious young misfits set off an island-wide search after running away together in 1960s New England.

The Grand Budapest Hotel (2014)
A concierge and his protégé pursue a priceless painting in a fictitious war-torn Eastern European country.

Isle of Dogs (2018)
A boy travels to a dystopian wasteland on the outskirts of a futuristic Japanese city to retrieve his lost dog.

The French Dispatch (2021)
An anthology of stories concerning the residents of a fictional French city over the course of several decades.

Asteroid City (2023)
A theatrical troupe rehearses a play about a space convention interrupted by an alien in an American desert town.

SHORT FILMS

Bottle Rocket (1994)
Hotel Chevalier (2007)
Prada: Candy (2013)
Castello Cavalcanti (2013)
Come Together: A Fashion Picture in Motion (2016)
The Wonderful Story of Henry Sugar (2023)
Poison (2023)
The Ratcatcher (2023)
The Swan (2023)

MUSIC VIDEOS

Tip-Top: 'Aline' (2021)

COMMERCIALS

American Express: My Life. My Card. (2006)
SoftBank (2008)
Stella Artois: Le Apartomatic (2010)

INDEX

35mm film 93, 143

A
accent colours 40, 41
accessories, *see* props
adjusting, *see* photo exercises
Adobe Lightroom 16
adolescence, *see* coming-of-age narrative
advertisements, Wes Anderson 153
aesthetic, *see* style
American Express commercial (2006) 153
analogue film, *see* cameras, analogue film
anamorphic, *see* lenses, anamorphic
Anderson, Eric Chase 84
Anderson, Wes
 commercials, music video
 and short films 153
 Asteroid City (2023)
 21, 110, 139-49, 153
 Bottle Rocket (1996) 19-27, 45, 153
 The Darjeeling Limited (2007)
 37, 66-77, 110, 153
 Fantastic Mr. Fox (2009) 78-89, 153
 The French Dispatch (2021) 128-39, 153
 The Grand Budapest Hotel (2014)
 102-115, 153
 Isle of Dogs (2018) 116-27, 153
 The Life Aquatic with Steve Zissou
 (2004) 37, 54-65, 153
 Moonrise Kingdom (2012) 90-101,
 139, 153
 The Royal Tenenbaums (2001)
 37, 42-53, 153
 Rushmore (1998) 29-41, 153
 see also, style, Wes Anderson's
Andersonian arrangements, still-life,
 with props 136-9
angles 11, 17, 23, 27, 53, 57, 79-89, 127, 149
 see also, field of view
animation 78-89, 116-23
anthology film 131
antiheroes 45
aperture 17, 41, 127
apps, *see* software, photo-processing
architectural features 15, 27, 109, 115,
 139, 145, 149
 see also, buildings

Asteroid City (Anderson, 2023) 21, 25,
 110, 139-49, 153
asymmetry 53, 69, 105, 115
Atkins, Annie 132
atmospheric shots 21, 35, 145
auction houses 139

B
backdrops and background 15, 17, 27, 40,
 41, 53, 57, 63, 65, 69, 77, 89, 101, 109, 115,
 127, 138, 139, 143, 144, 149
backlighting 17, 27, 149
backstory 46, 77
balance, *see* colour, grading; composition;
 framing
Baldwin, Alec 45
beige 31
Belhadjine, Mohamed 132
black-and-white film 21, 144
Blanchett, Cate 57, 59
blocking, of actors 59
blue 30, 31, 33, 34, 41
blurring 17, 41, 127
boat, *see* ship
Bottle Rocket (Anderson, 1996) 19-27,
 45, 153
 short film (Anderson, 1994) 21, 153
brief, *see* communication, with subjects
Britten, Benjamin
 Noye's Fludde 93
Brody, Adrien 68-73, 108
brown 31, 32, 127
buildings 11, 140-9

C
callbacks 47, 49, 123
cameras
 analogue film 11, 93, 143
 DSLR 11, 15, 53
 mirrorless 15
 smartphone 11, 15, 53
Capture One 16
Cassel, Seymour 45, 57, 59
Castello Cavalcanti (short film,
 Anderson, 2013) 153
Cavazos, Lumi 22
Chalamet, Timothée 132-4

characters 15, 45, 59, 77, 81, 84, 89, 93,
 125, 127, 143, 144
 see also, personality
Chinchón, Spain 21, 143
cinematic effect 11, 16, 17, 45
cinematographer, for Wes Anderson
 20, 21, 57, 93, 143
clarity 15, 16, 41, 127
claustrophobia, see space
clean lines, see clarity
Clooney, George 81
close-ups 47, 59, 90–101
clothes, see costumes
cluttered images 26
 see also, space
colour 15, 21, 29–41, 53, 77, 105, 127,
 138, 139, 149
 bold 15, 139
 conveying mood or evoking emotion
 11, 29–41
 drab, muted, subdued 21, 31, 32, 35,
 37, 127
 grading 16, 37
 palette 11, 21, 31, 37, 127
 pastel 11, 31, 33, 34, 37
 profile 16
 saturation 16, 37
 symbolism 31–7
 temperature 16, 115
 wheel 40, 41
columns, see architectural features
comedy-drama 31, 57
 see also, humour, visual
Come Together: A Fashion Picture in Motion
 (short film, Anderson, 2016) 153
coming-of-age narrative 31, 35, 93
commercials, Wes Anderson 153
communication, with subjects 65, 77, 101
complementary colours 40, 41
composition 15–17, 27, 53, 57, 70, 138, 139
 balance 11, 15, 17, 41, 65, 70, 77, 89, 99,
 101, 105, 109, 115, 127, 138, 139, 143, 149
 symmetry 11, 15, 53, 63, 65, 69, 77, 89,
 101–115, 139, 144, 147–9
compression, of an image 17
context 45, 81, 115, 131
continuity 70
contrast 16, 17, 21, 37, 127, 139
costumes 11, 31, 41, 53, 77, 89, 101, 105
Cox, Brian 33
Cranston, Bryan 119–21
crispness, see clarity

D
Dafoe, Willem 80, 81
The Darjeeling Limited (Anderson, 2007)
 37, 66–77, 110, 153
daydreams, see dreams
deep focus, see focus, deep

depth 16, 17, 64, 65, 133
 of field 17, 57, 127, 143
detail, attention to 16, 105, 111, 122,
 131, 139, 144, 149
development, see photo exercises; skills,
 developing and refining
direction, see communication,
 with subjects
dogs 119–23
dollhouse aesthetic 105
doors, see architectural features
dreams 30, 31, 33, 37, 108
DSLR, see cameras, DSLR
dynamic
 range 37, 93
 symmetry 108
 see also, group portraits; human,
 relationships; power dynamic

E
eBay 139
editing techniques 70
Edwards, Grace 145
emotion, see colour, framing, lighting, pose:
 conveying mood or evoking emotion
empathy 119
equipment 11
existential crisis, see human condition
experimentation, see photo exercises
exposure 15, 53
expressions, facial 41, 53, 65, 77, 89,
 93, 97, 101
exteriors 15–17, 27, 53, 143–9
 see also, landscape shots
eyeline 81, 89, 93, 101, 115
eyes, see faces

F
faces 16, 99–101, 115
 see also, expressions, facial
family 37, 45, 47, 59, 68, 69, 77, 97, 139
Fantastic Mr. Fox (Anderson, 2009)
 78–89, 153
features, see faces
fictional locations 15, 21, 31, 93, 119,
 131, 154, 153
field of view 17
Fiennes, Ralph 105–9, 111–15
film
 directors, see Anderson, Wes;
 Scorsese, Martin
 sets 11, 105, 109
 see also, 35mm film, cinematic effect,
 Super 16mm film
filmography, Wes Anderson 153
first-person point-of-view 45, 84,
 116–27
flashbacks 72, 92, 105, 119
flat-on shots 143

focus 15, 17, 27, 41, 63, 65, 139, 143, 144, 147
 deep 62–5, 143
 focal length 15
 focal point 15, 17, 41, 126, 127, 143
forced perspective 81
foreground 15, 69, 89, 111, 143, 144, 149
framing 11, 15, 17, 26, 31, 35, 53, 54–65, 105, 107, 119, 127, 143–5, 149
 conveying mood or evoking emotion 57–61, 69–73, 75–7, 81–9, 93–7, 99–101
 see also, composition
freezing motion 17
The French Dispatch (Anderson, 2021) 128–39, 153
French New Wave cinema 21
f-stops 17, 127

G

Gambon, Michael 80, 81
Gilman, Jared 92–7
Glover, Danny 47
God's-eye view 42–53, 84
golden hour, *see* magic hour
Goodfellas (Scorsese, 1990) 45
The Grand Budapest Hotel (Anderson, 2014) 102–115, 153
green 35, 41
grey 127
grids 17, 65, 101, 143
group portraits 66–77
Guinness, Hugo 80, 81

H

Hackman, Gene 44, 45, 47, 49
Hanks, Tom 144
Hayward, Kara 92–7
head-on shots 81
Hedges, Lucas 93
hero shots 81, 83, 86–9
highlights 16, 37, 41, 101
history, *see* retro style, time period
horizon line 15, 17, 27, 65, 110, 143, 149
Hotel Chevalier (short film, Anderson, 2007) 153
Houston, Texas 31
hues, *see* colour, grading
human
 condition 21, 57, 97
 relationships 23, 31, 35, 57, 69, 75, 77, 93–7, 105, 115, 119, 143
 see also, family
humour, visual 57–9, 82
Hurlstone, Robin 80, 81
Huston, Anjelica 45

I

instructions, *see* communication, with subjects
interactions, *see* human, relationships

interiors 15, 53, 59, 115, 139
intimacy 47, 53, 59, 71, 77, 93, 97, 101, 119
introspection 35, 59, 77, 84
Isle of Dogs (Anderson, 2018) 116–27, 153
isolation 37, 59, 64, 105, 107, 133
Ito, Akira 122, 123

J

Japan 119–23

L

landscape shots 17, 65
leading lines 17, 27, 89
learning, *see* photo exercises; skills, developing and refining
lenses 17, 143
 anamorphic 17, 57, 143, 145
 prime 15
 wide-angle 53, 65, 115, 149
The Life Aquatic with Steve Zissou (Anderson, 2004) 37, 54–65, 153
lighting 16, 17, 21, 26, 105, 115
 backlighting 17
 conveying mood or evoking emotion 16, 21–3, 26, 89
 light source 17, 115
 natural light 11, 17, 19–27, 65, 101, 149
 sunlight 16, 17, 21–3, 27, 89, 93, 143, 149
location 15, 39, 53, 65, 101, 115, 127, 131
 natural 15, 27, 53, 101
 urban 15, 143, 149
loneliness, *see* isolation
long-exposure photography 17
love 22, 34, 47, 93, 97
 see also, romance
low-angle shots 78–89, 101, 145

M

magic hour 16, 17, 21–7
manual settings, on cameras 15
masculinity 37, 45
match cuts 70, 72
McCole, Steve 37
McDormand, Frances 133, 135
Mean Streets (Scorsese, 1973) 45
memory, *see* nostalgia
mental health 21, 47
metanarratives 47, 109, 143
metaphor 59, 71
midground 143
midtones 37
mirrorless, *see* cameras, mirrorless
monochrome, *see* black-and-white film
mood, *see* colour, framing, lighting, pose: conveying mood or evoking emotion
Moonrise Kingdom (Anderson, 2012) 90–101, 139, 153
Moran, Kris 139
motion 17, 77

multiple shots for best effect, see photo exercises
Murray, Bill 37, 57, 59, 81, 131, 133, 135
Musgrave, Robert 21
music video, Wes Anderson 153

N
narration 45
narrative, see storytelling
　symmetry 109
natural
　light, see lighting, natural light
　locations, see location, natural
naturalism 21, 37, 39, 101, 105, 115, 132
negative space 17, 77, 143, 144, 149
nested storytelling, see metanarratives
New Wave Cinema, French 21
Nomura, Kunichi 122, 123
Norton, Edward 120
nostalgia 16, 22, 93, 132, 139
　see also, retro style

O
object 17
ocean, see sea
one-point perspective 17, 65, 108, 110
outdoor, see exteriors; location, natural
outfits, see costumes
overhead shots, see God's-eye view
over-the-shoulder shots 94, 95, 127

P
Paltrow, Gwyneth 45-8
panoramic compositions 57, 143
parallel lines 110, 119, 149
parents, see family
parodies, of Wes Anderson's style 11
paternal issues, see family
patience 16
patterns 16, 77
period, see retro style, time period
personality 16, 41, 45, 57, 75, 77, 89, 99-101, 127, 131, 139, 145
perspective 17, 45-53, 65, 81, 85, 97, 108, 110, 112-27
photo exercises 11
　Andersonian arrangements,
　　still-life, with props 136-9
　colour 38-41
　deep focus 62-5
　first-person perspective 124-7
　framing faces 99-101
　God's-eye view 50-3
　group portraits 74-7
　hero shots 86-9
　natural light 24-7
　shot-reverse shot 112-15
　wide-angle exteriors 146-9
placement, of objects, see props

planimetric staging 143, 144
point of view, see first-person point of view, perspective
Poison (short film, Anderson, 2023) 153
portraits 39, 66-77, 86-9, 99-101
pose, conveying mood or evoking emotion 27, 41, 53, 65, 77, 88, 89
post-processing, see software
power dynamic 45, 70, 81
practice 16
Prada: Candy (short film, Anderson, 2013) 153
prime lens, see lenses, prime
printed material, in Wes Anderson's films 36, 46, 119, 122
processing, see software
production designer, for Wes Anderson 143
props 15, 16, 41, 53, 77, 105, 107, 108, 111, 115, 119, 127-39
protagonists, see characters

R
radios 134
Rankin, Koyu 119-21
The Ratcatcher (short film, Anderson, 2023) 153
realism, see naturalism
real-world locations 15
red 31, 34-7, 41
reference images, see photo exercises
refining, see skills, developing and refining
　relationships, see family; human, relationships
repetition of shots 109, 133
retro style 11, 77, 132, 139, 142, 143, 149
　see also, nostalgia
reverse angle 105, 107, 119, 120
reviewing, see photo exercises; skills, developing and refining
Revolori, Tony 105, 107, 112-115
Robbie, Margot 144
romance 16, 22, 34, 47, 89, 93, 95, 97
Ronan, Saoirse 108
The Royal Tenenbaums (Anderson, 2001) 37, 42-53, 153
rule of thirds 17, 27, 41, 88, 89, 101, 149
Rushmore (Anderson, 1998) 29-41, 153

S
saturation, see colour, saturation; contrast
scale, sense of 144
scaled-down models 56, 57, 143
Schreiber, Liev 119, 123
Schwartzman, Jason 30-7, 68-73, 81, 83, 144
Scorsese, Martin 45
　Goodfellas (1990) 45
　Mean Streets (1973) 45
　Taxi Driver (1976) 45
sea 56-65

157

self-discovery, *see* coming-of-age narrative
set, *see* film, sets
　　set decorator, for Wes Anderson 139
setting, *see* location
setting up, a shot 11, 15, 16, 27, 41, 53, 65,
　　77, 89, 101, 115, 127, 139, 149
shadows 16, 17, 21, 37, 101, 115
shape 145
sharpness, *see* clarity
ship 56–9
short films, Wes Anderson 153
shot-reverse shots 93, 112–5
shutter 15, 27
　　speed 17
siblings, *see* family
side-on shots 109, 114, 115
silhouettes 17
skills, developing and refining 11, 15, 16
　　see also, photo exercises
sky 17, 27, 89, 143, 149
smartphone, *see* cameras, smartphone
Softbank commercial (2008) 153
software, photo-processing 16, 53
space 59, 69–71, 77, 93, 95, 97, 115, 143
stabilizing, a camera 15, 139
static shots 81, 108
Stella Artois commercial (2010) 153
Stiller, Ben 45, 47, 49
St. John's School, Houston, Texas 31
Stockhausen, Adam 143
stop-motion animation 116–27
storytelling 11, 16, 23, 31, 41, 45, 47, 53,
　　57, 69, 101, 105, 115, 119, 127, 131, 139,
　　143, 145
structures, *see* buildings
style
　　personal 11, 77, 89
　　Wes Anderson's 11, 15, 16, 19, 27, 31, 37,
　　　45, 57, 69, 77, 81, 89, 105, 119, 131, 139,
　　　143, 149
stylized worlds 15, 21
subjects 15, 17, 26, 27, 39, 41, 51, 53, 63–5,
　　77, 87, 89, 101, 113, 115, 127, 143, 149
sunlight, *see* lighting, sunlight
sunrise and sunset, *see* magic hour
Super 16mm film 93
sushi-making scene 122
The Swan (short film, Anderson, 2023) 153
Swinton, Tilda 97, 106, 145
symbolism, *see* colour, symbolism;
　　metaphor
　　symbolic perspective 84
symmetry, *see* composition, dynamic,
　　narrative

T

tableau compositions 71
Taxi Driver (Scorsese, 1976) 45
technology, vintage 134

temperature, *see* colour, temperature
terminology, photographic 11, 17
texture 16, 77, 127
thrift stores 139
time period 131, 132, 142–5, 149
timing 27
Tip-Top
　　'Aline' music video (2021) 153
tone 35, 37, 127, 131, 149
top-down perspective 119
tracking shots 108
train, with camera fixed 110
transistor radios 134
translation 119
tripod, *see* stabilizing, a camera

U

urban locations, *see* location, urban

V

vanishing point 17, 110
Vanity Fair 21
viewfinder 65, 149
vintage, *see* retro style
VSCO app 16

W

weather conditions, *see* lighting,
　　natural light
white 16
wide-angle shots 17, 23, 53, 57, 121,
　　127, 146–9
widescreen framing 17, 54–65, 93, 145
Williams, Olivia 31, 33
Willis, Bruce 97
Wilson
　　Laura 8–9
　　Luke 20–3, 45–8
　　Owen 21–3, 47, 49, 59, 60, 68–73
windows, *see* architectural features
Wolodarsky, Wallace 84
The Wonderful Story of Henry Sugar
　　(short film, Anderson, 2023) 153
world, creating a, *see* storytelling

Y

yellow 35
Yeoman, Robert 7, 9, 20, 21, 57, 93, 143

BIOGRAPHIES

ABOUT THE AUTHOR

Adam Woodward is a writer and author of *The Worlds of Wes Anderson*. He is Editor-At-Large at *Little White Lies* magazine, and has been watching films for a living since 2009. He lives in London with his partner Liz and their dog Mouse.

ABOUT THE PHOTOGRAPHER

Liz Seabrook is a London-based portrait and lifestyle photographer known for her engaging and authentic imagery. She thrives on exploring new places and connecting with people doing what they love. Her debut book, *The Female Chef*, was published by Hoxton Mini Press in 2021.

AUTHOR ACKNOWLEDGEMENTS

This book would not have been possible without my editor, Laura Bulbeck, who helped steer the project from its early stages and made sure it stayed on the right course. This was my second time working with her, following *The Worlds of Wes Anderson*, and both occasions have been an absolute joy from start to finish. My deepest gratitude also extends to Claire Warner for her exceptional work in designing and laying out the pages of this book and Renata Latipova for Quarto art direction. Thanks, too, to Andrew Roff, who first approached me with the idea of writing *Shoot Like Wes*. And to Akio Morishima for the nifty illustrations which accompany several of the photo exercises. Lastly, the biggest thanks goes to Liz for agreeing to join me on this little venture and for taking such beautiful photos—I really couldn't have done it without you.

Quarto

First published in 2025 by White Lion Publishing,
an imprint of The Quarto Group.
One Triptych Place, London, SE1 9SH,
United Kingdom
T (0)20 7700 9000
www.Quarto.com

EEA Representation, WTS Tax d.o.o., Žanova ulica 3,
4000 Kranj, Slovenia

Design copyright © 2025 Quarto Publishing Plc
Text copyright © 2025 Adam Woodward, except for
p7 © 2025 Robert Yeoman; pp8–9 © 2025 Laura Wilson
Cover photographs as stated on the cover.
Interior photographs copyright © 2025 Liz Seabrook
Illustrations copyright © 2025 Akio Morishima

Adam Woodward has asserted his moral right to be identified as the Author of this Work in accordance with the Copyright Designs and Patents Act 1988.

All rights reserved. No part of this book may be reproduced or utilised in any form or by any means, electronic or mechanical, including photocopying, recording or by any information storage and retrieval system, without permission in writing from White Lion Publishing.

Every effort has been made to trace the copyright holders of material quoted in this book. If application is made in writing to the publisher, any omissions will be included in future editions.

A catalogue record for this book is available from the British Library.

ISBN 978-0-7112-9680-0
Ebook ISBN 978-0-7112-9681-7

10 9 8 7 6 5 4 3 2 1

Design by: Claire Warner

Publisher: Jessica Axe
Commissioning Editor: Andrew Roff
Senior Editor: Laura Bulbeck
Senior Designer: Renata Latipova
Senior Production Controller: Rohana Yusof

Printed in China